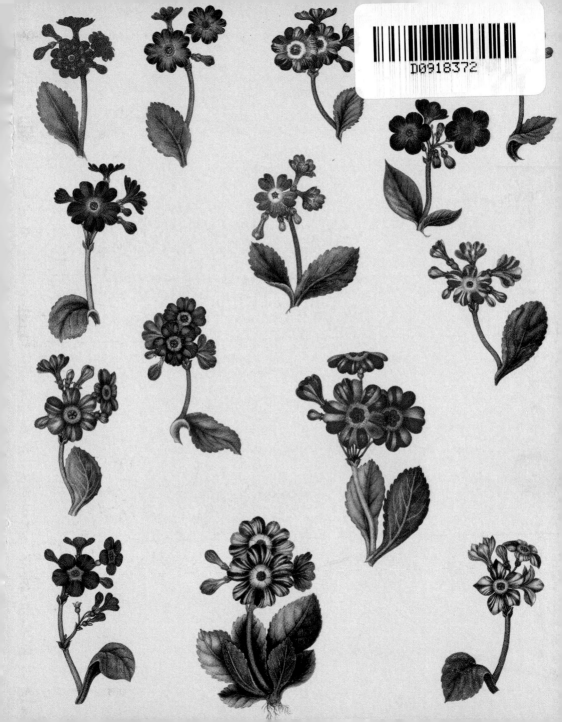

Mr. Marshal's *flower book*

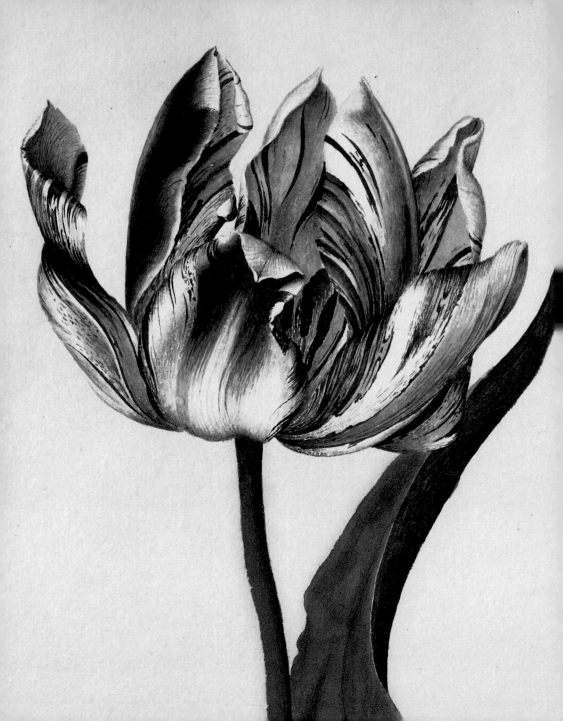

MR.
MARSHAL'S
flower book

Being a COMPENDIUM of the
FLOWER PORTRAITS
of
ALEXANDER MARSHAL Esq.

As created for his MAGNIFICENT
FLORILEGIUM

Here arranged by *SEASON* and supplemented
with an INTRODUCTION and COMMENTARY
and with a selection of plates from the ORIGINAL.

Viking Studio

VIKING STUDIO
Published by the Penguin Group
Penguin Group (USA) Inc., 375 Hudson Street, New York, New York 10014, U.S.A.

First American edition
Published in 2008 by Viking Studio,
a member of Penguin Group (USA) Inc.

1 3 5 7 9 10 8 6 4 2

The text for this book was abridged from *The Florilegium of Alexander Marshal* by
Henrietta McBurney and Prudence Sutcliffe. Royal Collection Publications gratefully
acknowledges their assistance in preparing the essays for the present volume.

ISBN 978-0-670-02038-6

Designed by Sally McIntosh

Editorial project management by Johanna Stephenson · Production by Debbie Wayment
Printed and bound by CS Graphics Singapore

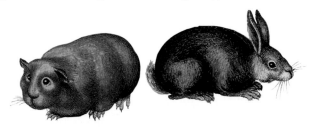

ALEXANDER
MARSHAL

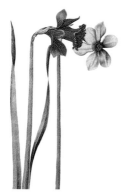
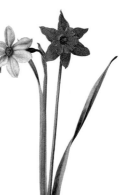

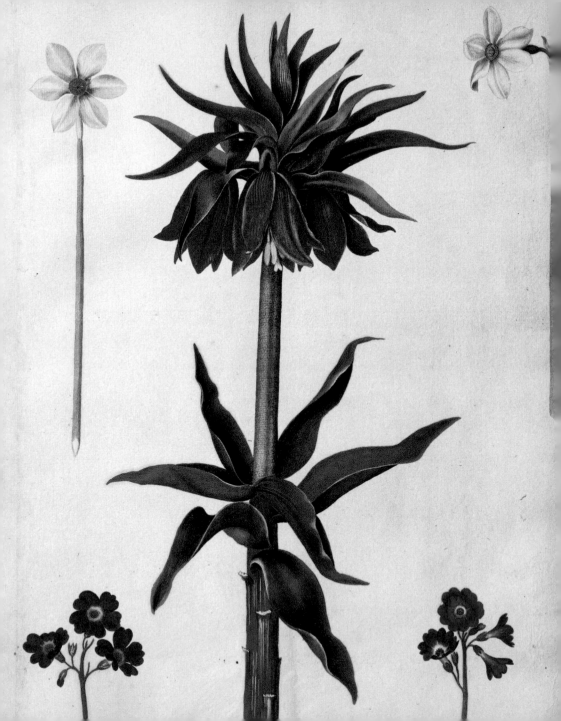

ALEXANDER MARSHAL

A Biographical Sketch

The 18 Mai came Mr Marshal the first time to my house to be
acquainted with me.

<div align="right">(The Diary of Samuel Hartlib, 1654)</div>

Alexander Marshal, the creator of the 'Flower Book' celebrated here, was a
gentleman of independent means whose circle of friends and fellow-gardeners in
seventeenth-century England included aristocrats, artists, botanists and collectors.
During his lifetime Marshal was known not only for his flower-paintings, or 'plant
portraits' as they have been described, but also as a horticulturalist and ento-
mologist. Yet despite his fame amongst his contemporaries, there is little in the
way of a documentary record to give us the details of his life – just three letters
from Marshal himself, his annotations to his own drawings, and the mentions of him
in the diary entries of the scientist and intellectual Samuel Hartlib (*c*.1600–1662),
who evidently became one of Marshal's closest friends. So far as we know, and
despite the fact that he gardened at two different sites in London, Marshal never
seems to have owned a permanent home of his own. Of his artistic works again only
a handful survive – some miniatures, two flower pieces, a group of insect drawings
and the *Florilegium*, or 'Flower Book', painted as a record of the flowers in his own
and his friends' gardens, and the sole surviving example of such a work from
seventeenth-century England. It is on this exquisite Flower Book – the beauty of its
drawing, the vividness of its colours and the charm of its design – that Marshal's
reputation as a pre-eminent botanical artist rests.

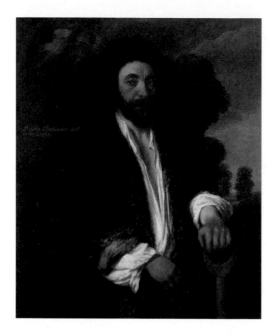

[LEFT]
Attributed to Thomas de Critz,
*Portrait of John Tradescant the
Younger*, c.1653; oil on canvas
(Ashmolean Museum, Oxford)

[OPPOSITE]
Rose and ground ivy from
the *Florilegium*, folio 208
(RL 24352)

There is, thus far, no evidence of Marshal's exact date of birth, but from the maturity of the voice in the earliest of his three surviving letters, from 1641, a date of birth has been suggested for him of around 1620. He may have been born and brought up in France, for Hartlib's first mention of his new acquaintance in his diary (1657) notes that Marshal 'hath lived for some years in Fraunce speaking French perfectly'. Indeed, Marshal's 1641 letter is written in French, even though we know it was written in England, to Sir Justinian Isham of Northamptonshire.

In 1641 Marshal was living in South Lambeth in London with the gardener John Tradescant the Younger (1608–62). Tradescant had inherited his garden, along with a celebrated museum popularly known as 'the Ark', from his father, John Tradescant the Elder (*c.*1570–1638). Both men are among the greatest names of English garden history, and the Tradescant museum was eventually to become a foundation collection of the Ashmolean Museum in Oxford. In 1638 Tradescant

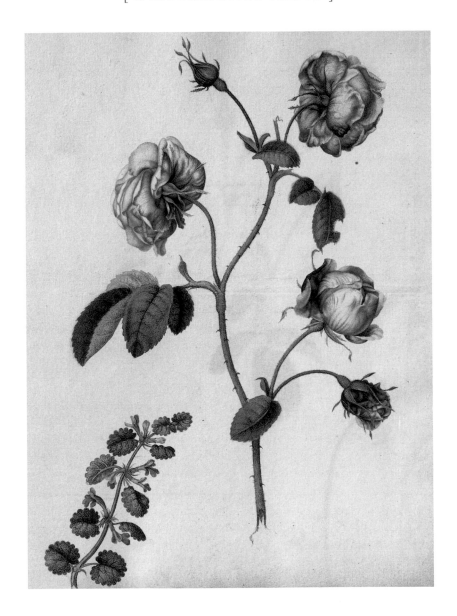

the Younger had succeeded his father to the royal post of Keeper of the Gardens, Vines and Silkworms at Oatlands Palace near Weybridge in Surrey, and had also made the first of three expeditions abroad in search of new plant species.

By the mid-seventeenth century new plants were arriving in England from all over the world – from the Near East, via ambassadors at the Ottoman court in Constantinople, or from the new French and British colonies in Canada and Virginia. They included not only seeds, but also bulbs and tubers of tulips, anemones, crown imperials, irises, hyacinths, lilies, turban ranunculi and narcissi. These beautiful and often highly scented flowers, emerging from such unpromising-looking material, made a tremendous impact when they first bloomed, and were highly sought after by English gardeners. This was an age when many large country houses were being built, often with splendid gardens, and there was a ready market for plants from abroad, with abnormal examples (such as doubles or those with unusually coloured flowers or leaves) being particularly prized. Many such specimens were recorded by Marshal in his *Florilegium*; and even before he began work on what was to be his 'own' book it seems that he had completed a flower book for Tradescant. This volume, listed in

[RIGHT]
Tulip from the *Florilegium*,
folio 42 (RL 24309)

[OPPOSITE]
Alexander Marshal, *Arrangement of Tulips*; watercolour and bodycolour over graphite on vellum
(British Museum, London)

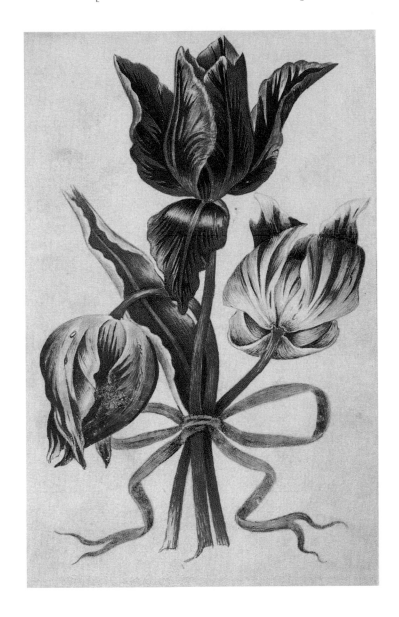

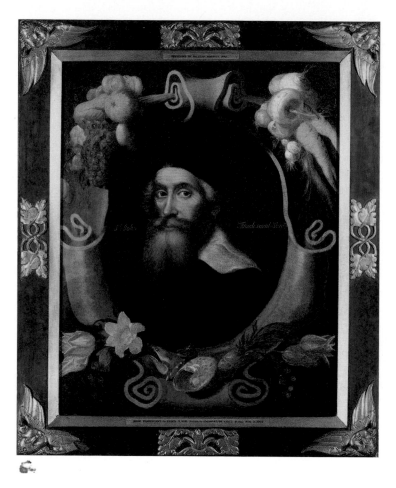

the *Musaeum Tradescantianum* (1656) as containing 'Mr. Tradescant's choicest Flowers and Plants, exquisitely limned in vellum, by Mr. Alex: Marshall', was probably that described six years earlier, without naming the artist, by Hartlib (who had still to meet Marshal): 'John Tradesken hath a booke very lively representing most of the th[ings] hee hath [in his garden]'.

Sadly, no trace of this early florilegium has survived, although some of the watercolours on vellum inserted at the end of the Windsor *Florilegium* may hint at the drawings executed for Tradescant. There is also in the British Museum a separate group of thirty-three early botanical watercolours on vellum by Marshal, which may date from this period (page 11). These show mainly tulips and anemones, in small bunches tied with coloured ribbons. Similar arrangements can be found in the work of the French artist Nicolas Robert (1614–85), with which Marshal may have been familiar.

A few other pieces by Marshal have also survived from the period up to 1650. While working on the florilegium for Tradescant he may have executed the surround of flowers, shells and vegetables in the posthumous portrait of the elder Tradescant that is now in the Ashmolean Museum. An indication of his technical skill – and activity – at this time is Marshal's 1649 copy of a miniature portrait of Katherine Bruce, wife of William Murray, 1st Earl of Dysart. Murray was another of Marshal's aristocratic friends; in the background in his copy of the portrait Marshal includes a view of the north front of the Dysarts' Surrey home, Ham House. The miniature is a valuable record of Marshal's technical accomplishment as well as his inventiveness.

*

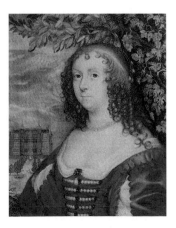

[OPPOSITE]
Attributed to Emanuel de Critz
(and Alexander Marshal),
John Tradescant the Elder,
1640s; oil on canvas
(Ashmolean Museum, Oxford)

[RIGHT]
Alexander Marshal after John Hoskins,
Katherine Bruce, Mrs Murray, 1649;
watercolour and bodycolour on vellum
(Ham House, Surrey)

The majority of Marshal's dated works are from the 1650s, by which time he had moved from South Lambeth and was living in Ham, where he may have rented property from William Murray. His works of this period include a miniature of a child, a swag of flowers, and further copies in miniature of works by other artists. In 1653 he was in Islington, where he had lodgings with the son of Alderman Jonathan Dawes. It is not known at what date he began his own *Florilegium*, although by 1653 he appears to have executed a significant part of it. Hartlib had certainly heard of it by then, writing that Marshal 'had a Picturary of his owne Herbary for wh[ich] hee had beene offered upon a Table 300. pieces of gold, but would not'. When the two men finally met a year later their conversation was wide ranging, and Hartlib's notes show that the subject of gardens and gardening was of the greatest mutual interest. He described Marshal as 'a Merchant by profession' and 'one of the greatest florists and deale[r]s for all manner of Roots Plants and seeds from the Indies and else where'. At this point Marshal had two gardens, one in Islington and the other in Northamptonshire 'at the Earl of Northamptons'. The latter was perhaps at Castle Ashby, for there is a supplement to a lease dated 20 March 1656 showing that the 3rd Earl of Northampton had given an 18-year lease on some fifty acres at Castle Ashby to Alexander Marshal 'of the citty of London esqr' and Benjamin Austin, rector of Castle Ashby, at a yearly rent of £57. In this second garden Marshal was growing both liquorice and 'true Rheubarb' with success. Among the other plants which we know Marshal was cultivating in his gardens were two star anemones, *Anemone pavonina* Lam., with red and white streaked petals, which are illustrated in the *Florilegium* and which Marshal may have bred himself (see above).

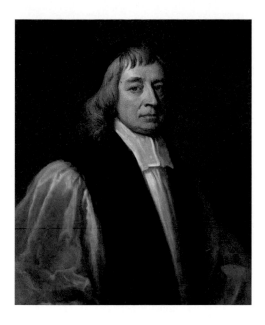

[OPPOSITE]
Star anemones, possibly bred
by Alexander Marshal, from the
Florilegium, folios 19 and 23
(RL 24286 and 24290)

[LEFT]
Sir Godfrey Kneller,
Henry Compton,
1700; oil on canvas
(National Portrait Gallery,
London)

By 1658 Marshal's drawings of flowers and fruit were so highly regarded that his work was considered 'comparable with any now beyond Seas'. Presumably he continued his horticultural activities in Islington and Northamptonshire until at least the early 1660s, and at the same time was adding watercolours to his *Florilegium*. But in 1667 Marshal left London to take up an appointment as Steward to the Hospital of St Cross outside Winchester, where Henry Compton, a younger brother of James, 3rd Earl of Northampton, was Master.

*

Henry Compton (1632–1713) was the third of Marshal's most important friends, after Tradescant and Hartlib. Compton and Marshal were to be closely associated from 1667 onwards; Compton was appointed Canon of Christ Church in 1669 and Bishop of Oxford in 1674, and when he became Bishop of London the following year Marshal accompanied him to Fulham Palace.

The gardens at Fulham Palace had been famous since the time of Bishop Edmund Grindall (1519–93), who was the first to grow a tamarisk tree there, in 1560. In 1647, some years before Compton's incumbency, a description lists:

> outhouses dovehouses barnes stables granaries coachhouse courts courtyards orchards gardens walkes fishponds pumpes watercourses ... two foote bridges and one greatt bridge and three closes of pasture called the Warren which premise are all encompassed with a moate ... flooded and drayned att pleasure and doe conteyne together within the said moate thirtie six acres and an halfe by admeasurement.

Compton resided at Fulham for thirty-eight years, and was recorded as having 'above 1000 Species of Exotick Plants in his stoves and Gardens, in which last place he had endenizon'd a great many that have been formerly thought too tender for this cold climate'. With overseas chaplains under his authority, he was well placed to acquire rarities from abroad, and opened his garden to all the leading botanists of the day. Parts of the garden survive, and a fine holm oak, still standing at the south corner of the lawn, is considered to be one of the oldest in the country and may even pre-date Bishop Compton's tenure.

*

By 1667 Marshal's skill as a painter, or 'limner', was such that the newly established Royal Society asked him to set out the means by which he obtained his vivid colours. His response was read to members of the Royal Society on 19 December 1667. One of the many subjects in which the Royal Society was interested was the composition of artists' pigments – other artists approached at the same time included the portrait painter Peter Lely (1618–80) and the miniaturist Samuel Cooper (1608–72). Sir Theodore Turquet de Mayerne (1573–1655), the eminent physician, had also assembled notes on the colours used by artists, while Robert Boyle (1627–91), the natural philosopher and chemist, had published a book on the subject.

[ABOVE] Holm oak, Fulham Palace Garden

Interestingly, in his letter to the Royal Society (see pages 34–5) Marshal states that poor eyesight has forced him to turn from watercolours to oils. Few of his oil paintings can be found today – the only works definitely attributed to him are the exquisite *Flowers in a Delft Jar* of 1663 and *The Siege of Magdeburg*, the central portion of which is based on an engraving by Matthias Merian (father to another famous botanical artist, Maria Sibylla Merian) which was published in 1662. The *Siege* is perhaps the only acknowledgement we have in Marshal's surviving works of the turbulence of the times in which he lived – through civil war, the Interregnum and the Restoration of Charles II in England, and the immense upheavals of the Thirty Years War in Europe. Otherwise our image of him might simply be that of the solitary artist painting in his garden. It is also worth

remembering that there were many works other than his flower book by which Marshal's friends would have judged his skill – an oil painting on panel of *Christ at the Column*, perhaps after Van Dyck and signed 'Alex Marshal', was last recorded in 1929; he also made copies of royal portraits and of works by earlier masters, such as two signed and dated copies of *St Jerome in his Study* after Quinten Metsys, made in 1650 using watercolour and bodycolour on vellum. Marshal's knowledge of the works of earlier artists would have been based on careful study – in his letter to the Royal Society Marshal says 'Certainly Brugell, and Elshamer, and other masters had a way in Cleansing or Curing of their Colours, which is as yet to bee seene in their small Curious works as fresh as ever they were'.

During his lifetime Marshal's reputation as an entomologist was at least as great as his reputation as an artist. Hartlib described him as 'stupendiously excellent in all manner of Insects', and as having 'a whole Chamber of Insects w[hi]ch make a glorious representation'; the diarist and gardener John Evelyn (1620–1706) compared Marshal's insect collection to that of '*Mon' Morin* that rare Florist of *Paris*, who preserved & kept them [his insects] ranged in flat and shallow draw Boxes furnishing a Cabinett with such flies as drew the greatest princes of Europ to visite and admire them'.

There seems to have been an intention on Marshal's part to publish the results of his studies of insects; certainly his friends were keen for him to do so. In addition to annotating a copy of Thomas Mouffet's *Theater of Insects* (London 1658) and adding about fifty of his own drawings of insects to it, Marshal compiled two further volumes of drawings of insects accompanied by numerous annotations giving detailed descriptions of their behaviour. These notes make it clear that Marshal reared many of his own specimens of moths and butterflies, while others were collected in Fulham or at Castle Ashby, and more came from friends and acquaintances at home and abroad. One butterfly came from 'Mis[tress] Winter', the wife of Thomas Winter, a neighbour in Fulham, and one from 'Mis[tress] Morrison', wife of Thomas Morrison of Isleworth. Another butterfly was sent by John Evans, chaplain to the East India Company's station at Hugli in West Bengal,

and a harlequin beetle by Sir Henry Moody, who had emigrated to Massachusetts. Two 'sword flies' from Ethiopia reached Marshal through a Captain Chamberlaine, one of which he passed on to Vespasien Robin, who was gardener and botanist to successive French kings.

Thirty-eight different species of insect are to be found amongst the pages of the *Florilegium*. They are depicted with Marshal's usual care, though there are occasional anatomical inaccuracies, and generally they seem to be placed on the page according to the artist's whim, simply in celebration of their intriguing beauty.

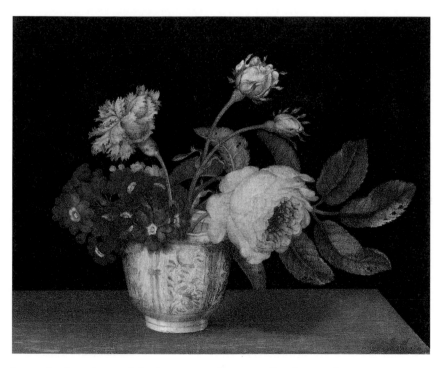

[ABOVE] Alexander Marshal, *Flowers in a Delft Jar*, 1663(?); oil on panel
(Paul Mellon Collection, Yale Center for British Art, New Haven)

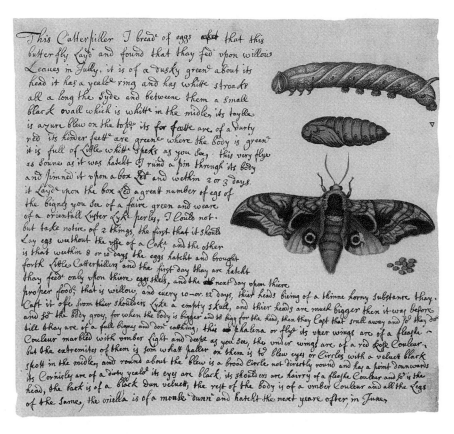

This Catterpiller I breade of eggs that this
butterfly Layd and found that thay fed vpon willow
Leaues in Iully, it is of a dusky green about its
head it has a yeale ring and has white stroaks
all a long the Sydes and betweene them a Small
black ovall which is white in the midles its tayle
is azure blew on the tope its for feete are of a durty
red its hinder feete are greene where the body is greene
it is full of Litle white speks as you See, this very fly
as Soune as it was hatcht I rund a pin through its body
and pinned it vpon a box Led and wethin 2 or 3 days
it Layd vpon the box Led a great number of egs of
the bignes you See of a faire green and weare
of a orientall Luster Lyke perles, I coule not
but take notice of 2 things, the first that it should
Lay eggs without the vse of a Coke, and the other
is that wethin 8 or 10 days the eggs hatcht and brought
forth litle Catterpillers and the first day thay are hatcht
thay feede only vpon thiere eggs shels, and the next day vpon thiere
proper food, that is willow, and euery 10 or 12 days, thier heads being of a thinne horny substance thay
Cast it ofe from thier shoulders Lyke a empty skull, and thier heads are much bigger then it was before
and so the body grow, for when the body is bigger and so bing for the head, then thay Cast that srall away and so thay do
till thay are of a full bignes and don cething, this phalena or fly its vper wings are of a fleshe
Couleur marbled with vmber Light and deepe as you See, the vnder wings are of a red Rose Couleur,
but the extremites of them is som what paler on them is to blew eyes or Circles with a veluet black
spott in the midles, and round about the blew is a broad Circle not directly round and has a point downwards
its Cornicles are of a durty yeale its eyes are black, its shoulders are hairry of a fleshe Couleur and so is the
head, the back is of a black Dun veluet, the rest of the body is of a vmber Couleur and all the Legs
of the Same, the oriella is of a mouse Dunn and hatcht the next yeare ofter, in June

The final chapter in Marshal's life was his marriage, on 26 July 1678, to
Dorothea Smith, a woman 'of noble birth' who had connections in Northampton-
shire. They had no children, and apparently lived together at Fulham Palace.
Compton's garden was still providing Marshal with plants to add to his *Florilegium*;
visiting on 1 August 1682, John Evelyn recorded in his diary: '& thence to *Fulham*

to visite the *Bish*: of *London*, & review againe the additions which *Mr. Marshall* had made of his curious booke of flowers in minature, and Collection of Insecta.'

Sadly, Marshal's marriage to Dorothea was to be a short one. On 7 December 1682 Alexander Marshal died – without leaving a will, which suggests that his death came without warning. He was buried on 13 December 1682 before the altar in Fulham parish church, and the inscription on his tombstone includes the following:

> He left no issue, but, by reason of his integrity and gifts he will live longer than the life which was vouchsafed him.

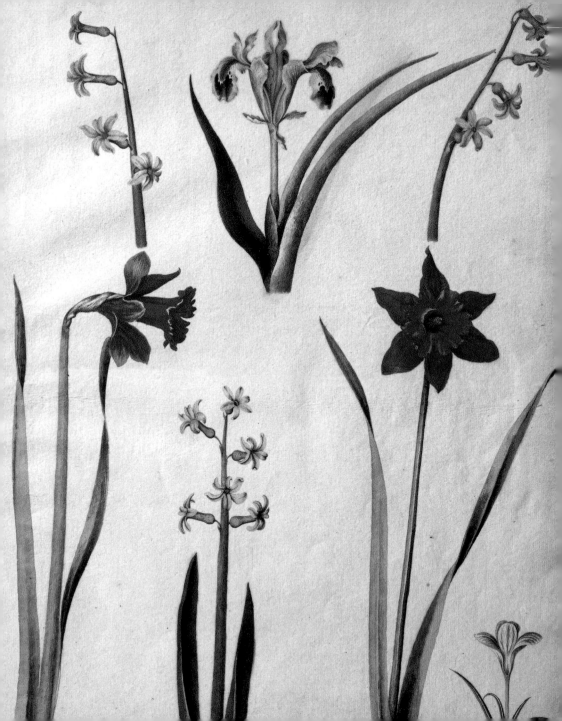

MR. MARSHAL'S
Flower Book

This Book was the Work of A Gentlemen, who married the Sister of my Fathers Mother. He had an independent fortune and painted merely for his Amusement. – He is said to have had a particular art of extracting Colors out of the Natural Flowers; and some of the Plants and Flowers contained in this Volume are painted with those Colors. This secret, though left behind him, died with those to whom he intrusted it. – He lived many years in great friendship with Dr Compton Bishop of London and died in his Palace at Fulham; where he planted several Cedars of Libanus (still growing there) and raised many other Exotics from America and Other Countries, the first that are known to have been raised in this Island. – After his Decease Five hundred Pounds were offered (by the Ambassador of France for his Master Louis XIV) and refused for this Volume by his Widow, who by her Will left it – with several of his Works and Valuable Curiousities – to my Father Doctor Robert Freind.

(Dr William Freind, *c*.1760)

[ABOVE] Alexander Marshal's *Florilegium* before disbinding

The pages of the *Florilegium* measure approximately 460 x 333 mm, but it is clear that they have been trimmed by at least 1–2 cm on all edges, very probably when the album was rebound in the early nineteenth century, immediately before it entered the Royal Collection. Six different papers were used by Marshal, four of which bear the watermarks of Italian or French manufacturers. A few of the pages noted over the years as in the *Florilegium* have gone missing, and some drawings, including some small studies pasted in presumably by Marshal, have been moved from their former positions.

In all Marshal illustrates 284 species of plant on 159 folios. His drawings are arranged more or less seasonally (as was the usual practice in such books), starting with winter-flowering plants such as aconites and crocuses and working through the year to autumnal species such as Chinese lanterns and saffron. He depicted approximately sixty tulips, thirty roses, sixty carnations, thirty-eight auriculas,

and forty-five anemones. Tulips, carnations and auriculas, particularly flowers of two colours, were all fashionable at this time, but Marshal did not paint only exotics: he appears to have derived as much pleasure and satisfaction from drawing simple wild flowers such as a sprig of sweet briar or lady's bedstraw. Furthermore, he was realistic in accepting the natural world as it was and did not always choose perfect specimens – he included flowers with blemished leaves and fallen petals. This can be seen as typical of Marshal's blend of accuracy and spontaneous informality, bringing his technical skill and meticulous observation to the depiction of wild flowers as well as fashionable florists' varieties.

Most of the plants are identified in Marshal's hand by their contemporary Latin and English names. A few are also named in French: for example, the ragged robin is annotated 'in French, Cuidrelles or Coucou Jilieflouer'. However, several of Marshal's names do not agree with the plants they represent, suggesting that he identified plants from whatever sources were available to him – such as John Parkinson's *Paradisi in Sole Paradisus Terrestris* of 1629, or Thomas Johnson's revised edition (1623) of John Gerard's famous *Herball*, first published in 1597.

The overall condition and, above all, the colours of the drawings seem so little touched by time that one can understand why his contemporaries, dazzled by his results, believed that Marshal must have some trick for extracting, mixing and preserving his colours. In general his technique is straightforward: he rarely employed underdrawing, painting a layer of watercolour directly onto the paper and adding details in transparent washes using fine, parallel brushstrokes.

[RIGHT]
Carnation from the *Florilegium*,
folio 124 (RL 24391)

Highlights were applied in lead white, with occasional touches of gold, or were achieved by leaving the paper bare. Marshal sometimes added a thin application of shiny gum arabic over his pigments, to enhance their depth of colour.

In his letter to the Royal Society, Marshal speaks of preparing his own colours, both mineral pigments ('which I turne into Laks, or dry them in Shels, which I temper with such waters, as I make fitt for them and my use') and vegetable pigments (which 'I make out of flowers, or berries, or gums or roots ... [which] are more subtill and have not so greatt a body as Minerals'). But despite his reputation as a 'man of Experiments', most of the colours he used were traditional. His favourite green was copper green (copper carbonate), often modified with the pigment gamboge, a yellow sap-resin from the trees of the genus *Garcinia*. A brighter turquoise green (used, for example, in the dead jay on folio 5) is probably verdigris, and he also used terre-verte, a pigment made from green earth. However, a fourth green is likely to have been one of Marshal's experimental colours. It can be seen, for example, in the two lower plants on folio 144 (also illustrated opposite), where it can be distinguished clearly from the terre-verte used for the balloon pea in the centre of the page.

For his pinks Marshal used the traditional rose or red madder (from the roots of the madder plant, *Rubia tinctorum* L.). His reds tended to be the orange-red vermilion or cinnabar (mercuric sulphide, used for many of the lilies) and the darker red lakes (carmine or cochineal extracted from the dried bodies of insects). For his browns and blacks he used traditional earth colours – ochres and carbon black. In his letter to the Royal Society he makes a point of stating that 'the Search of Colours has Cost me much time in finding out, and to know, which would hold Colour in water, and mix well, else I had not used them in my booke'.

*

For how many years was Marshal working on the *Florilegium*? We know from Hartlib that he had executed a significant part of it by 1653, and an early addition is evident from Marshal's note on the verso of his drawing of the Guernsey lily: 'this

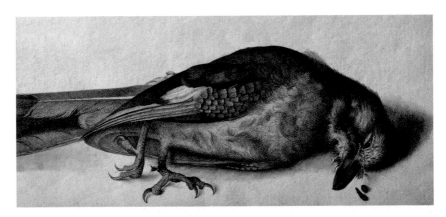

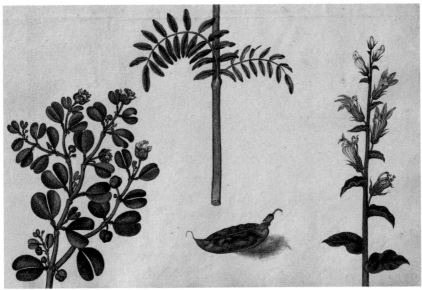

[ABOVE] Dead jay, detail from the *Florilegium*, folio 5 (RL 24272)

[BELOW] Syrian bean caper, balloon pea and blue cardinal flower, detail from folio 144 (RL 24411)

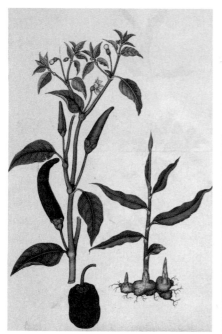

flower was sent me by Generall Lambert august 29 1659 from Wimbleton'. A drawing of ginger is annotated 'the trew figure of Ginger as it grew att Fulham', and was probably, therefore, done after 1675. The exotic cormorant-like bird on folio 2 (opposite) seems to have been that presented as a New Year's gift to the Prince of Orange (the future William III) on the occasion of his visit to Oxford in December 1670. As late as 1682 John Evelyn inspected 'the additions' made to Marshal's book – he recorded previous visits to Fulham in 1679 and 1681, and though he did not mention the *Florilegium* in connection with those visits, he may well have seen it. His flower book therefore seems to have accompanied Marshal throughout the last three decades of his life, and despite its growing fame it remained his own personal record of the plants that most interested and delighted him.

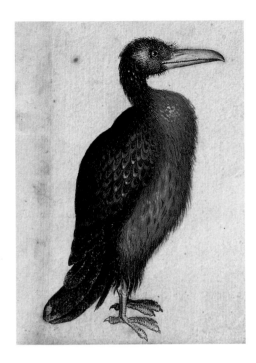

[OPPOSITE]
Hot pepper and ginger, detail
from the *Florilegium*, folio 146,
with annotation 'the trew figure
of Ginger as it grew at Fulham'
on the reverse of the sheet
(RL 24413)

[LEFT]
Cormorant, ('indian fowll')
detail from folio 2 (RL 24269)

Personal to its creator as it may have been, Alexander Marshal's *Florilegium*
must nonetheless be seen in context, as part of a particularly seventeenth-century
phenomenon. The term 'florilegium' was first employed in this sense in 1590 by the
Flemish artist Adriaen Collaert (1560–1618). His *Florilegium* was printed in Antwerp,
and was one of a number of printed florilegia produced on the Continent in the
years around 1600, the most notable of which were Pierre Vallet's *Jardin du Roy*
(Paris 1608) and Basil Besler's *Hortus Eystettensis* (Eichstatt 1613). Painted florilegia
– portraits of flowers from particular gardens, made to delight their owners –
were part of the scientific concern of the age, to record, identify and classify.

Most florilegia were produced in France, the Low Countries and Germany.
Some, such as Marshal's own *Florilegium* and that of the Dutch glass painter Pieter

van Kouwenhoorn (*c.*1630), were compiled for the artist's own pleasure; others were produced for great patrons, such as that made by Nicolas Robert (1614–85) for Gaston d'Orléans, brother of Louis XIII, at his gardens at Blois. In Germany one of the foremost artists was Johann Walther (*c.*1604–77) who recorded the plants in the garden created by the Count of Nassau at Idstein, near Frankfurt, in a florilegium painted between *c.*1651 and 1670 (and thus contemporary with Marshal's). Walther invariably showed his subjects to their best advantage, without blemishes, and often arranged regularly in rows.

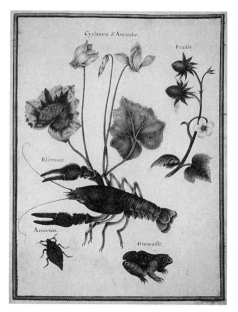

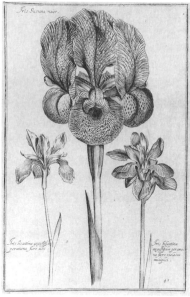

[ABOVE]
Nicolas Robert, *Crayfish*, *Frog*, *Cyclamen and Wild Strawberry* (Robert Album, folio 57); watercolour and bodycolour on paper (Fitzwilliam Museum, Cambridge)

[ABOVE]
Daniel Rabel, *Iris Susiana maior* (*Theatrum Florae*, Paris, 1622, plate 45); engraving (Natural History Museum, London)

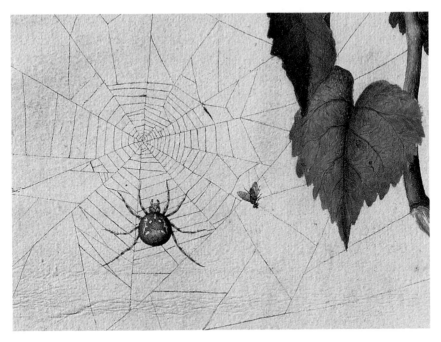

[ABOVE] Spider's web, detail from the *Florilegium*, folio 140 (RL 24407)

Marshal's *Florilegium*, however, is the only significant surviving example of native botanical art produced in England in the seventeenth century. Marshal was an amateur artist, and we know nothing of his training. He appears not to have been apprenticed to an established artist, and he could have honed his skills by copying the works of other artists; during his obscure early years in France he may have encountered the botanical works of both Rabel and Robert. Indeed, there is a similarity of approach between Marshal and Rabel, particularly in their arrangement of flowers on the page (compare, for example, Rabel's much-admired *Iris Susiana maior*, illustrated opposite right, and Marshal's *Iris Calcidonica*, folio 58; see page 116). Each also gave prominence to insects and animals painted alongside the plants.

Marshal clearly wanted his drawings to be recognisable portraits of plants. He understood their structure and wished to depict their details accurately. But many of Marshal's botanical drawings also display some of the characteristics of Dutch still-life painting, with details shown as if lying on a surface and casting a shadow. Sometimes individual petals or flower-heads are shown dropped from their stems; sometimes a whole plant stem, a fruit, bird or animal will be shown as if lying on a surface. Realistic features are introduced, such as dead leaves and flowers, drops of water, holes in leaves made by caterpillars or insects feeding off the plants. These insects are painted in great detail and sometimes at different stages of their development, an indication of Marshal's entomological interest.

Overall, the *Florilegium* displays a mixture of artistry and informality – qualities of all the best gardens and gardeners. Paradoxically, the naturalness of Marshal's arrangements seems to result from an intuitive sense of design. In some pages elegance is achieved through the informality, even whimsy, of the compositions; in others the drawings on the page are balanced with meticulous care, using a second view; the addition of an animal, bird or insect (see the Java sparrow on folio 119, illustrated opposite); or an extra touch of colour. This unique combination of qualities reflects the fusion in Marshal's art of Continental and native influences. In his own time he was recognised as one of 'Our Modern Masters comparable with any now beyond the Seas' – a description that does no more than assign him his rightful place amongst the great botanical artists of the seventeenth century.

*

Marshal's widow, Dorothea, kept her husband's flower book until her own death, in Chelsea, on 30 July 1711. Most of her estate, including the *Florilegium*, was bequeathed to her eldest nephew, Dr Robert Freind, the headmaster of Westminster School. Along with others of Marshal's papers, it subsequently passed to his son, Dr William Freind (1715–66), Dean of Canterbury. Some years after his death, William Freind's effects were sold by Messrs Christie and Ansell on 25 April 1777; lot 46 was described as 'A volume of FLOWERS finely executed from Nature in

watercolours by Mr. Marshall, containing 164 pages'. It fetched £52.10s and was bought, together with Marshal's two volumes of insect drawings and two other drawings, by an otherwise unknown Mr Way.

By 1818 the *Florilegium* had found its way to Brussels, where it was purchased for John Mangles by his friend Ross Donnelly. Mangles reordered parts of the *Florilegium*, removing a number of the drawings and rebinding it in two volumes. He inscribed volume I: 'John Mangles – Hurley, Berkshire/27 April 1820', added misleading notes concerning both the artist and the work's provenance (including its supposed ownership by William, Prince of Orange), renumbered the folios in pen and ink, and compiled a two-page index. Soon after, he presented the *Florilegium* to King George IV, and Marshal's greatest work has been in the Royal Library ever since. A programme of conservation in the 1990s saw the work disbound once more and the leaves individually housed to prevent damage through future handling.

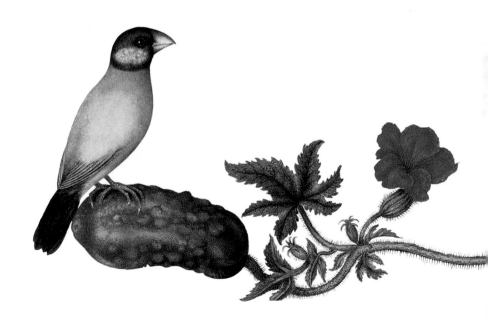

ALEXANDER MARSHAL'S LETTER TO THOMAS POVEY,
THE SECRETARY OF THE ROYAL SOCIETY, DATED 30 NOVEMBER 1667:

Sr,

I had answerd yours, had it Come to My Hands souner, I am very willing to
Satisfie in part your Desier conserning my Colors, but how to express the
handling of them I know not, for practice puts me in a new way every day,
that one Colour may sett out the other, by Composition or transparance,
which Leaves the beauty, as the flower or other things requyer, I thought
Seven years agon, that I Knew much, but I find, that practice shews me
dayly more then I Knewe before; but the Last weeke I tryed one Colour, and
Calcined it in three severall pots, and in one fyre together; the pots bieing
Cold, I found in them three severall Colours which was but one att first; the
one was red, the other yellow, and the other umber, and all very good for
use. As for the Colours I make out of flowers, or berries, or gums or roots;
they are more subtill and have not so greatt a body as Minerals, which I
turne into Laks, or drye them in Shels, which I temper with such waters, as I
make fitt for them and my use; the Searche of Colours has Cost me much
time in finding out, and to know, which would hold Colour in water, and
mixe well, else I had not used them in my booke, and am shure will bee as
fresh a hundred years hence, as when you Saw them Last. The truth is, they
are pretty Secrets, but Knowne they are nothing. Severall have been att me
to know how, as if they weare but tryfles and not worth Secrecy. To part
with them as yett I desier to be excused. I have in a mannor given over
water Couleurs, finding it tedious and forcible to the eys which has put me
upon the practice in oyle, And I am in good hopes, that my Colours will
shew themselves as beautifull in oyle as in water, Though many will say,
that it is needles; for oyle-Couleurs to be soe orient or beautifull in painting,
in my opinion 'tis a greate prejudice to painters, also to paint carelesly with
any Colours that will starve, and become nothing, by a Salt that is in them.

Certainly Brugell, and Elshamer, and other masters had a way in Cleansing or Curing of their Colours, which is as yett to bee seen^e in their small Curious works as fresh as ever they were; for, Salt and Oyle Can not agree Long, and so^e were parted by those masters, that ther fame might Last as well for their couleurs as work^e, Sr, I beg your pardon not knowing whether my abrupt Discourse dos answer your desire, and so I Rest,

> Sr, your humble & most
> oblidged servant
> Alex: Marshal

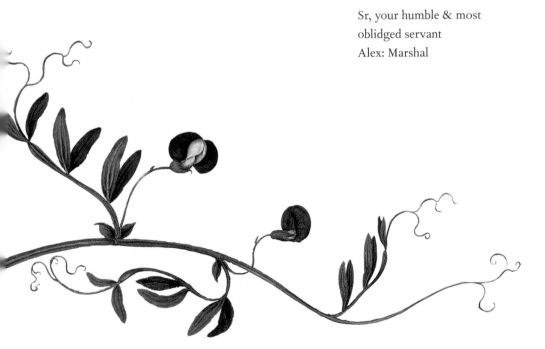

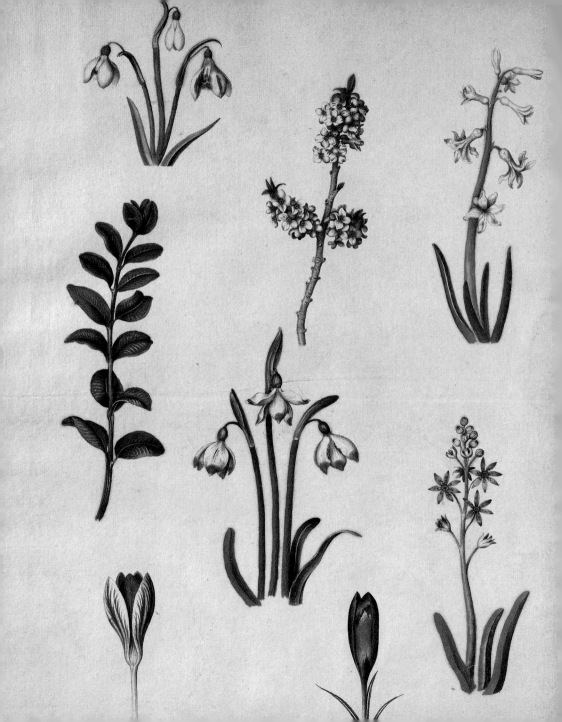

WINTER

Alexander Marshal's winter-flowering plants in the *Florilegium* include many species recognisable as stalwarts of the English winter garden today – crocuses, daffodils and narcissi, aconites, snowdrops, early-flowering violets, and fritillaries. For Marshal and his contemporaries, however, some of these were relatively new introductions – the 'Second Cloth of Gold' crocus, for example (*Crocus susianus* Ker-Gawler; see overleaf, right) – noted in 1629 by the apothecary and botanist John Parkinson as prospering well 'in our gardens'. Equally successful was the aconite (page 42), noted by Gerard as early as 1529 to be growing in 'great quantitie' in London. Gerard also had cyclamen – known as 'sowbread' because the leaves were a favourite food of pigs – growing in his garden.

Snowdrops, squills and the spring snowflake were all native plants, as were sweet violets and primroses, of course. But hyacinths, or 'jacinths', were more recent introductions, as 'the greates orientall Jacinth' (page 46) hints in its name. Pink and double forms in particular seem to have been rarities. Of the daffodils, the archetypal yellow trumpet daffodil (page 51), now naturalised in so many parts of the British Isles, was still referred to as the 'Spanish daffodil' (or even as 'the great bastard Spanish daffodil'), perhaps recording the plant's mixed origins and rugged opportunism.

By contrast *Daphne mezereum*, another native British plant, has become a rarity, and is today found in the wild only in chalk woodlands. On the same sheet (page 36) Marshal illustrates the margined box, *Buxus sempervirens* L. Marginata, described by Parkinson as 'but lately come to our knowledge'. Its delicate gold-edged leaves are a reminder of the role foliage plays in enlivening a winter garden, while the poignant study of a dead jay from folio 5 of the *Florilegium* (detail illustrated on page 27) perhaps suggests a more melancholy response to the passing of the year.

Although Marshal's ordering of plants by season is fairly loose, the 'indian fowll' (page 29) presented to the Prince of Orange as a New Year gift is indeed depicted, on folio 2 of the *Florilegium*, with such winter flowers as crocuses and aconites.

The 'drooping star of Bethlehem' (page 44) is one of the many plants in the *Florilegium* known to have been ordered from Brussels by the elder Tradescant for the gardens at Hatfield House. Other plants ordered by Tradescant for Hatfield include the hyacinth to its left.

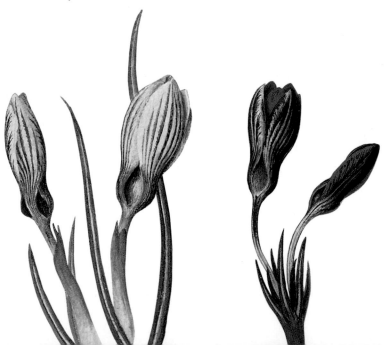

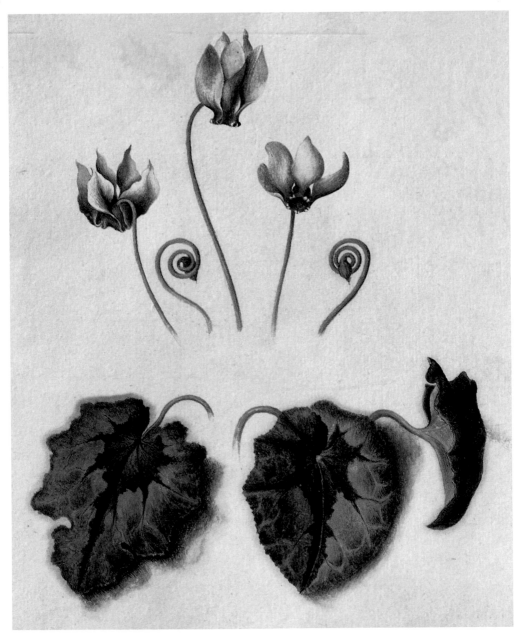

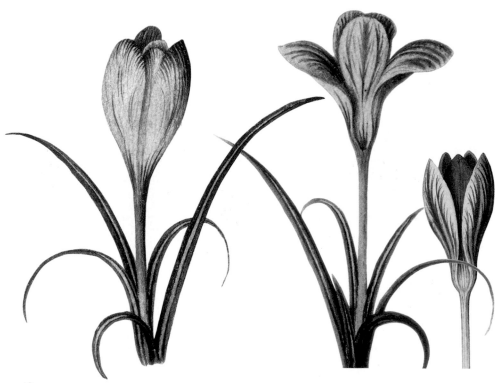

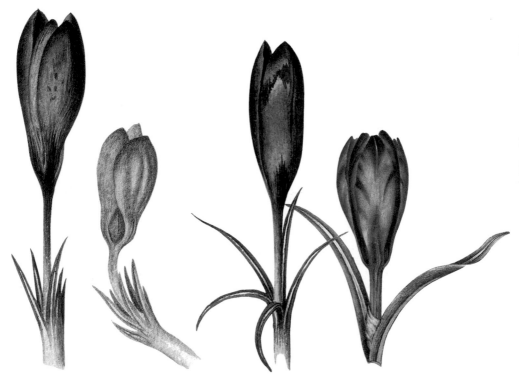

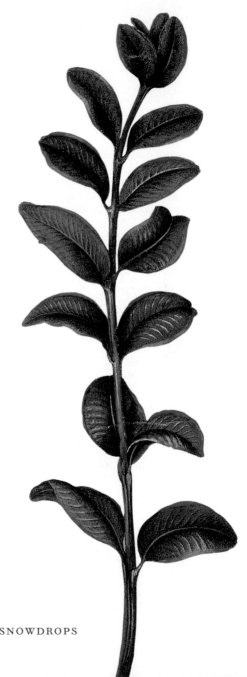

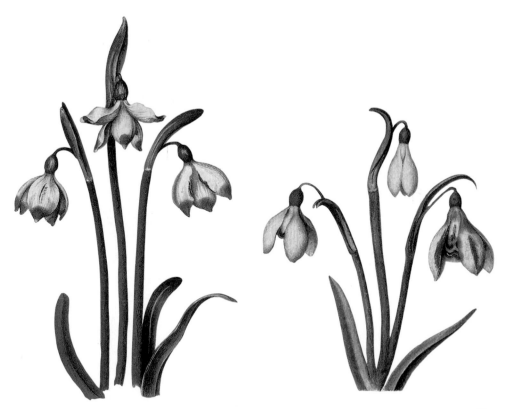

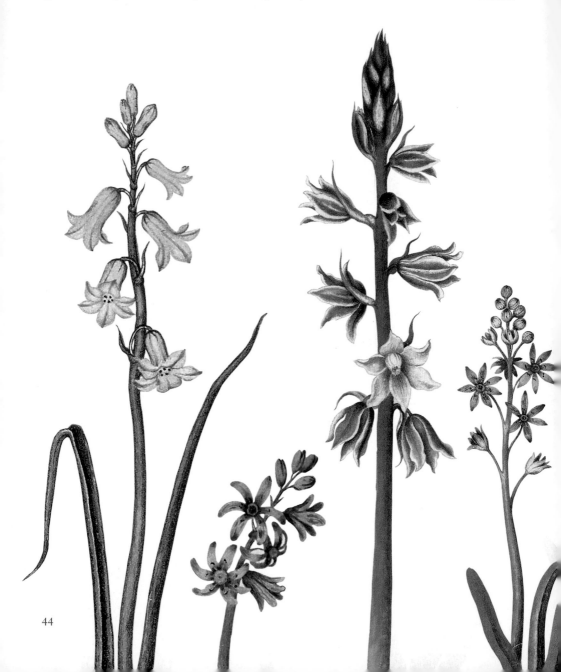

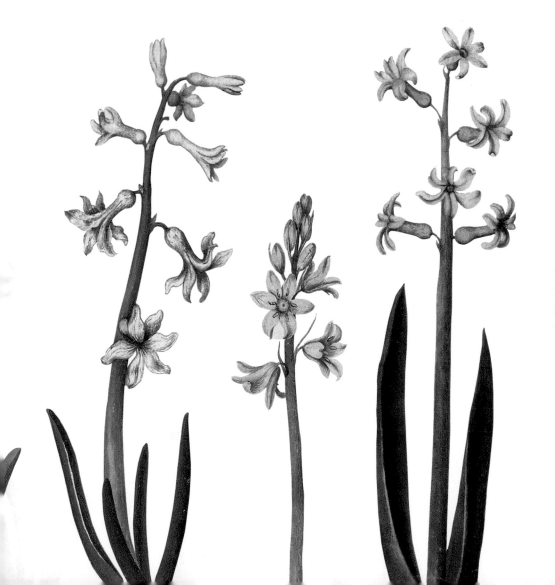

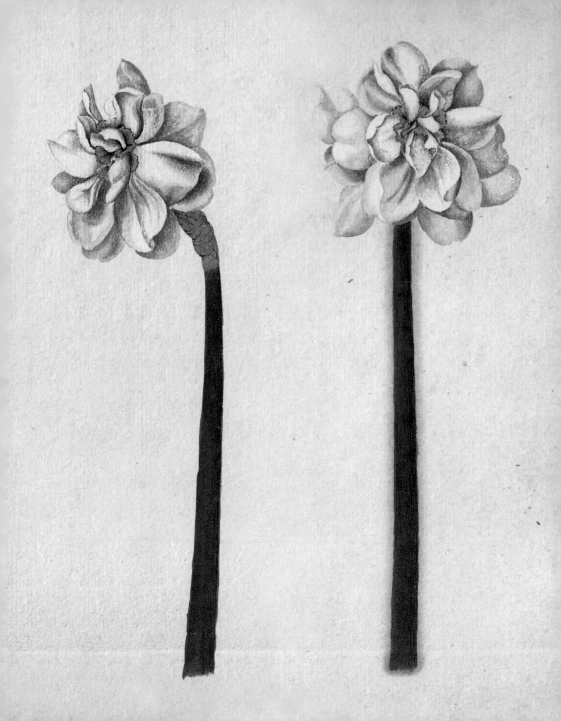

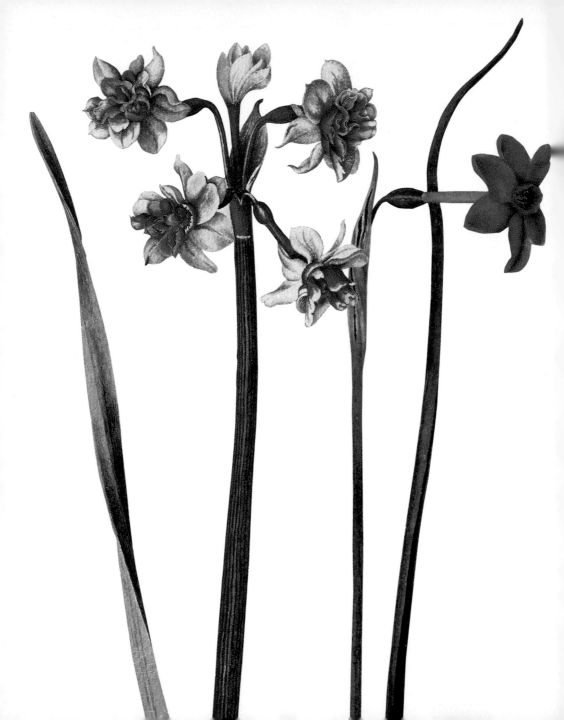

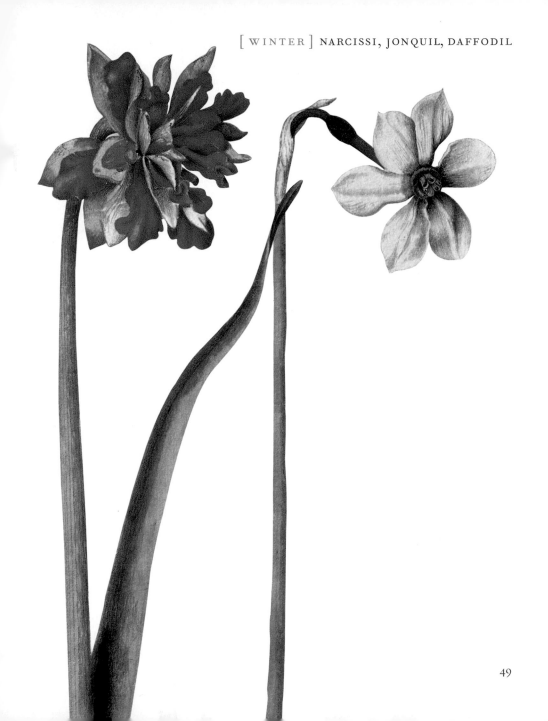

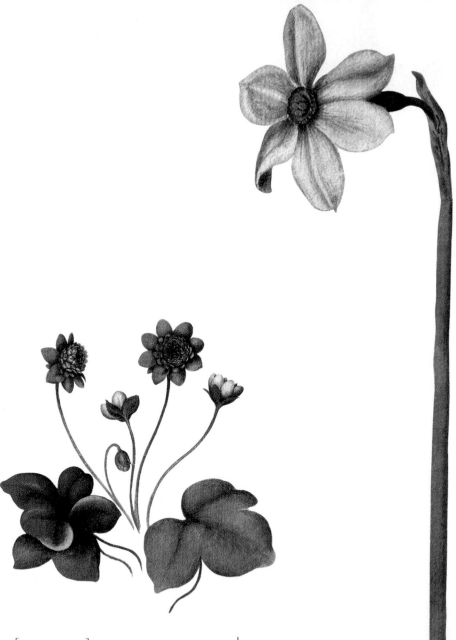

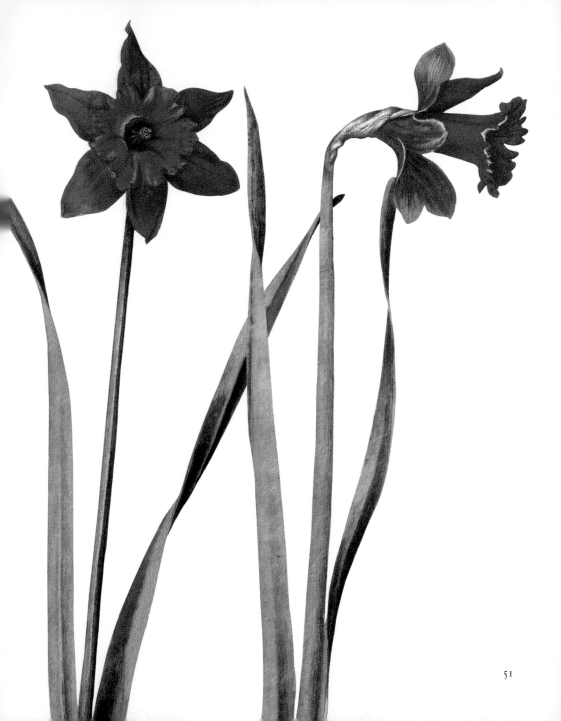

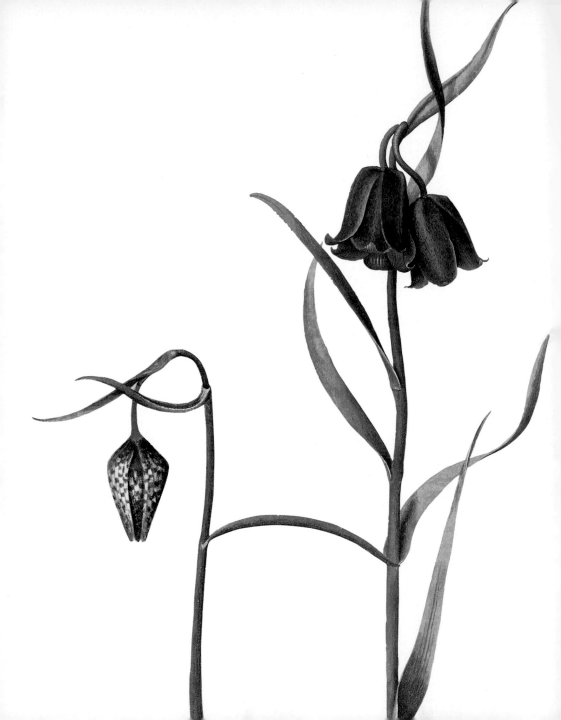

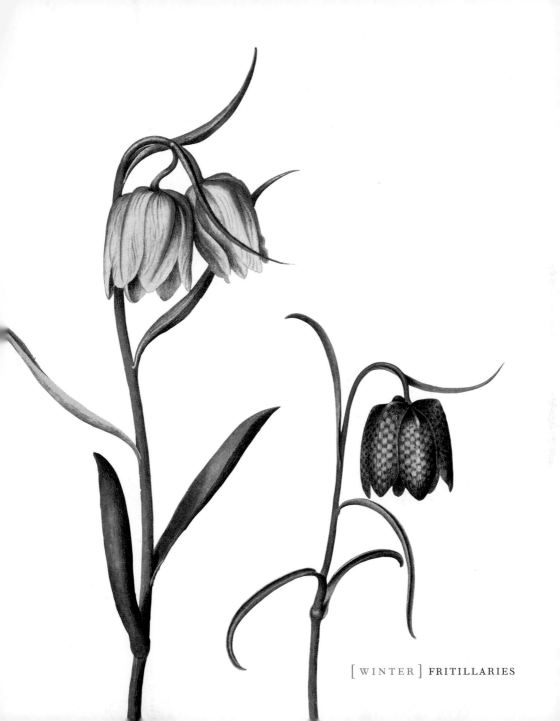

[WINTER] FRITILLARIES

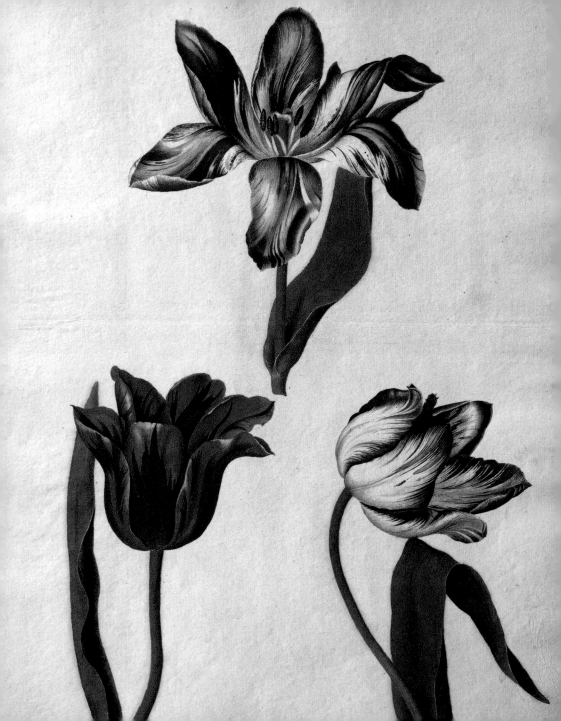

SPRING

The stars of Marshal's spring flowers are undoubtedly the tulips, represented in fourteen separate studies. Almost all display the flamed and feathered patterns so prized in the seventeenth century – as John Evelyn wrote, 'it is not the quantity of the Colour which renders a Tulip famous, so much as the quality, vivacity, agreeable mixture & position of them ...'. These flamed and feathered patterns are caused by a virus that greatly weakens the bulb and means that such tulips bloom highly unpredictably, or not at all – only increasing their rarity and worth to the devoted collector. Thus were the foundations of the famous Dutch 'tulipomania' laid.

Tulips come from Turkey (the name 'tulip' is derived from the Turkish word for turban), and were apparently first grown in London by James Garrett (d. 1610), a London apothecary and gardener. One of the most valuable tulips illustrated by Marshal was the 'Vis Roy' (page 77). Another (page 80) was noted as having been grown by Tradescant the Younger in 1656. Sir Thomas Hanmer, in his *Garden Book* of 1656, wrote, 'wee did value in England only such as were well stript with purples and other redds'. But fashions change: 'now ... we esteeme (as the French doe) any mixture of odde colours', Hanmer noted – rather sadly, one feels. Marshal shows one specimen (page 82) of a tulip named 'la damoiselle' where the misshapen leaf has partly taken up the broken colouring of the flower.

Other flowers for the spring garden in Marshal's day included, then as now, the bright, candy-striped varieties of primrose, or auricula – again the subject of much selective and skilful breeding. Striped forms, as in tulips, were especially prized; the double striped form (top left, page 63) was a particular rarity. And then there were anemones, which we know to have been bred by Marshal himself. Originally from Greece and the eastern Mediterranean, these flowers were being cultivated in English gardens in both single and double forms by the 1590s. The modern anemone evolved from these flowers in the nineteenth century. Then as now they had the poetic common name of 'wind flowers'.

Marshal also found a place in his book for native plants including heart's-ease – parent of our modern pansies – and lily-of-the-valley. However, the St Bruno's Lily (page 72) was a new introduction. Listed by the elder Tradescant in 1610, it was said to have been first grown in England by the Huguenot merchant John de Franqueville, and it was another of the plants ordered for Hatfield House.

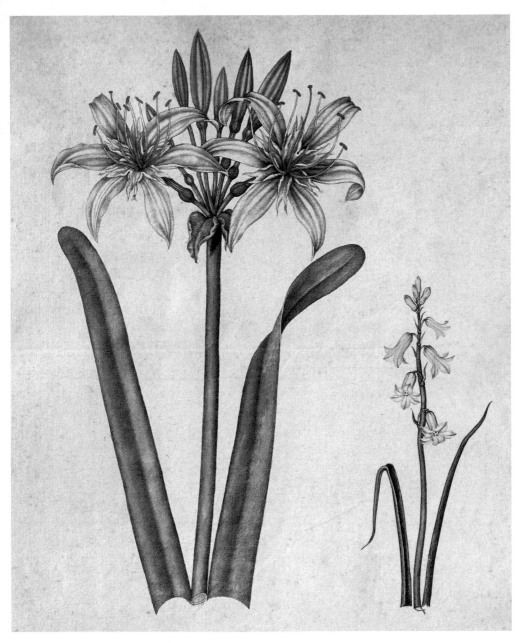

[SPRING] ILLYRIAN SEA DAFFODIL, HYACINTH 57

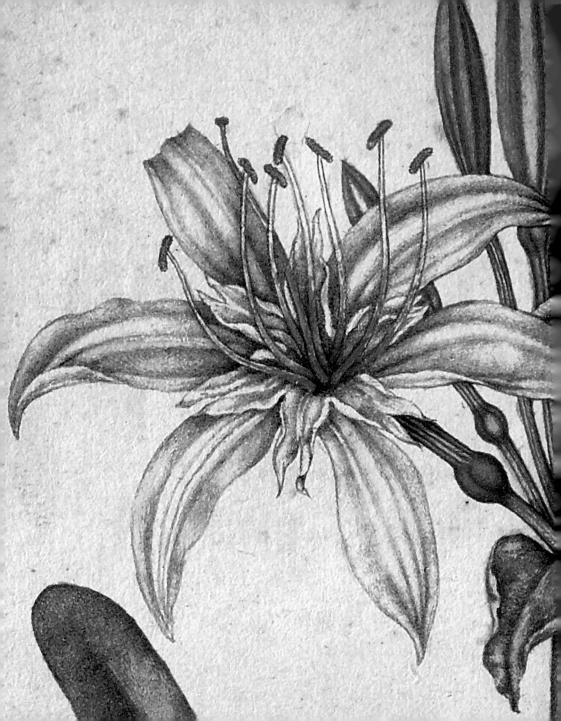

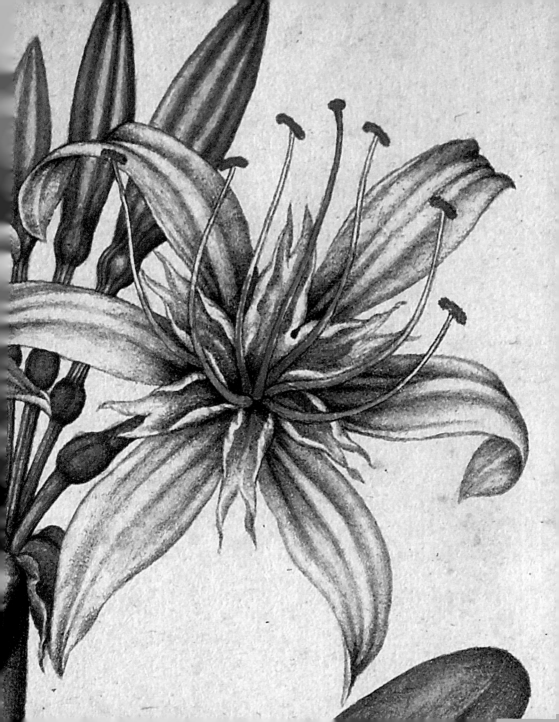

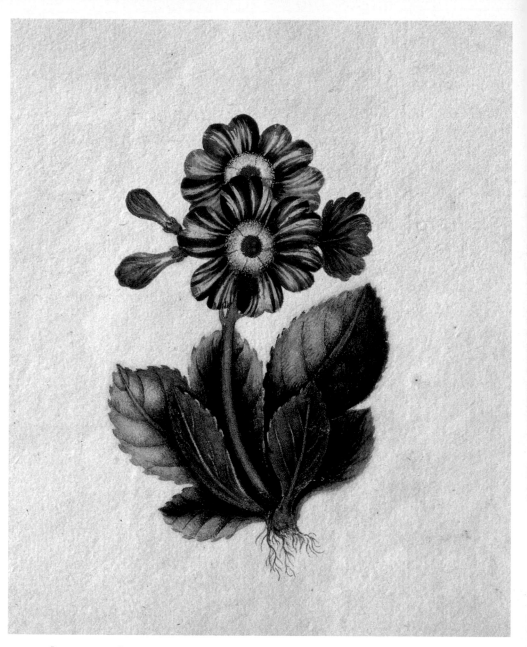

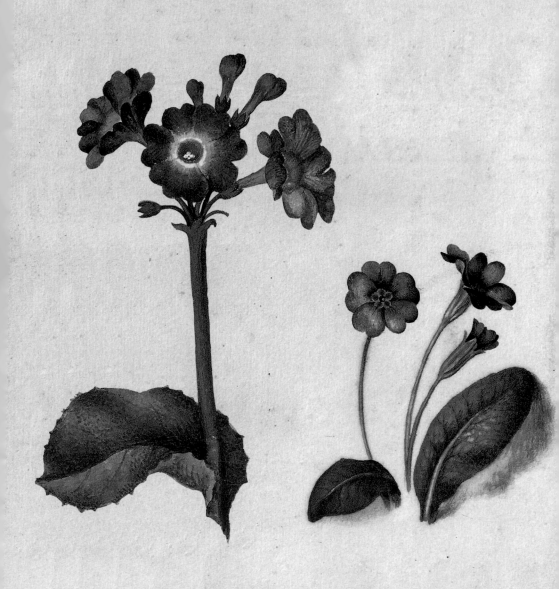

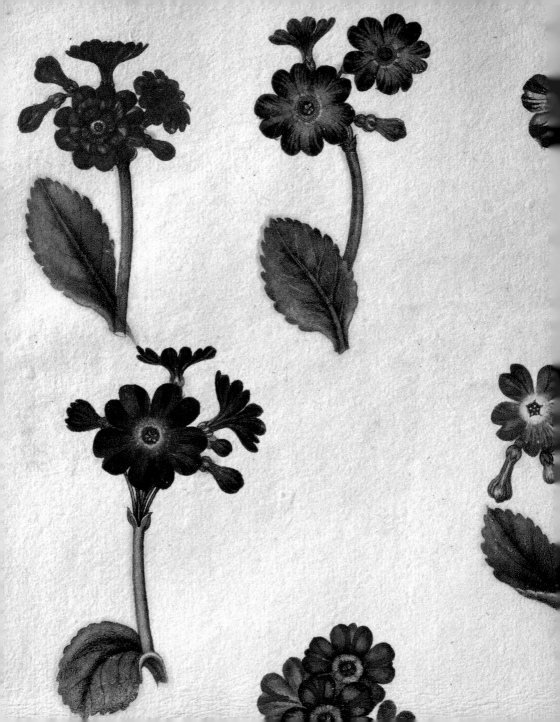

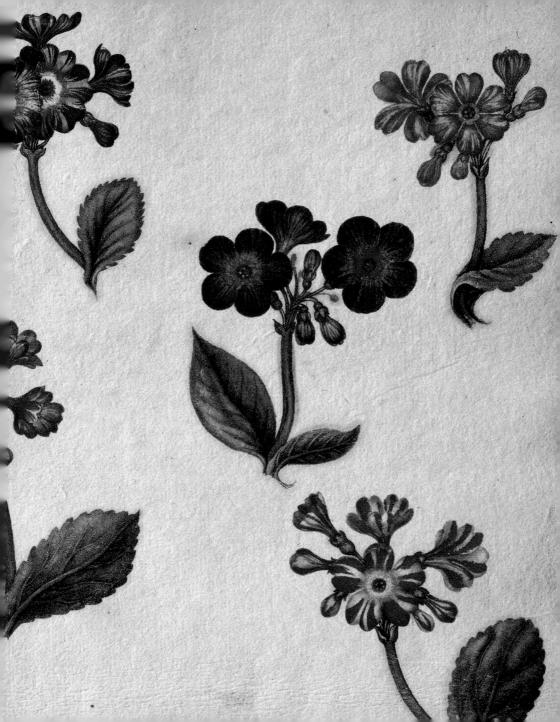

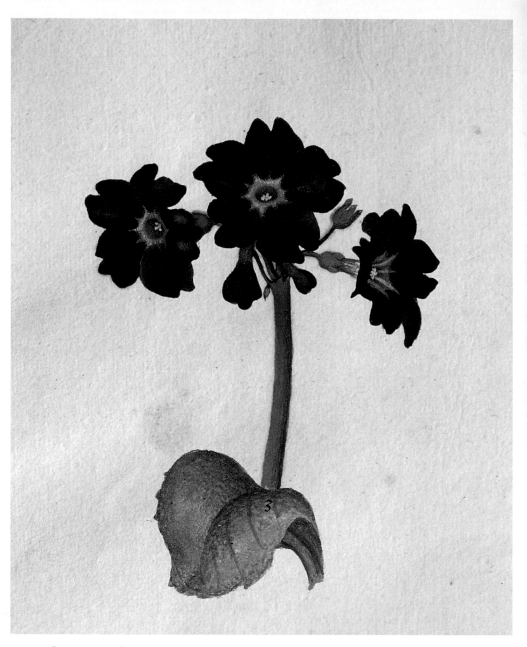

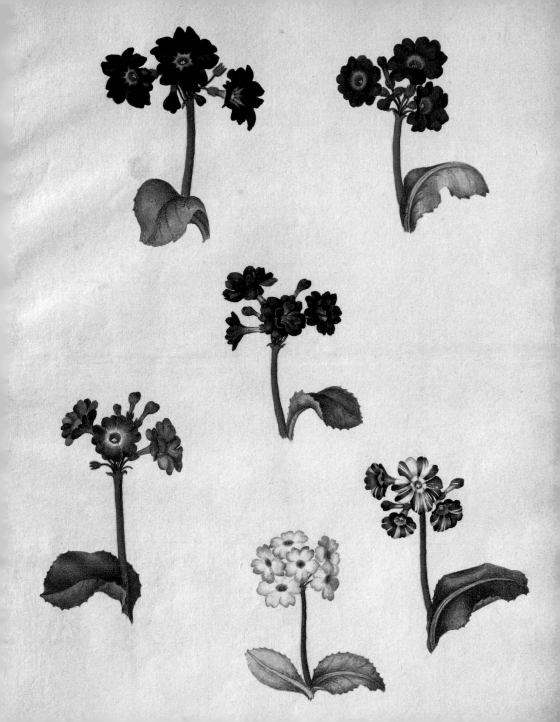

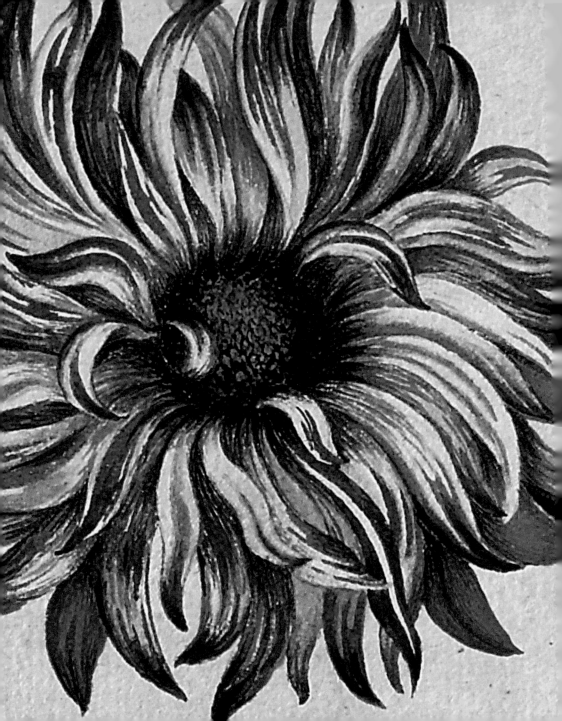

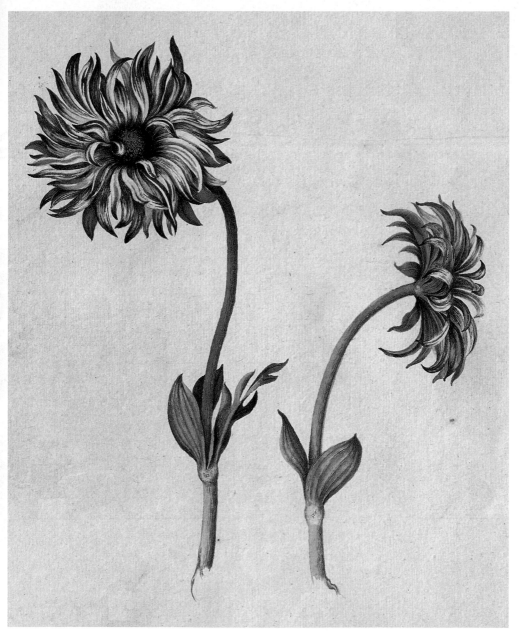

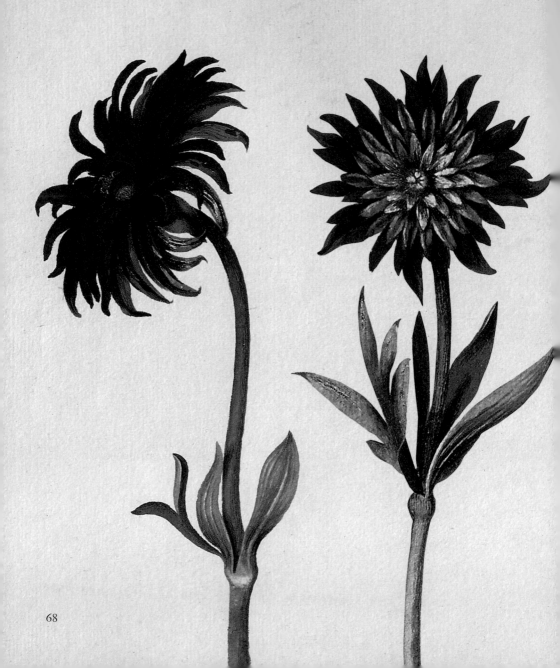

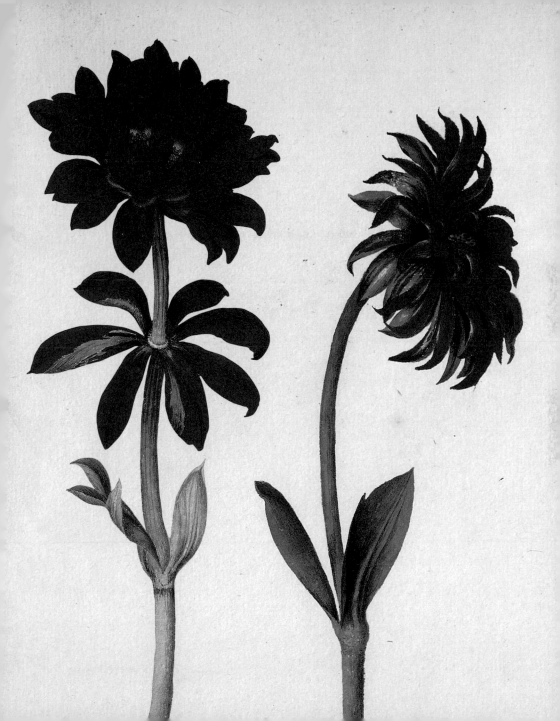

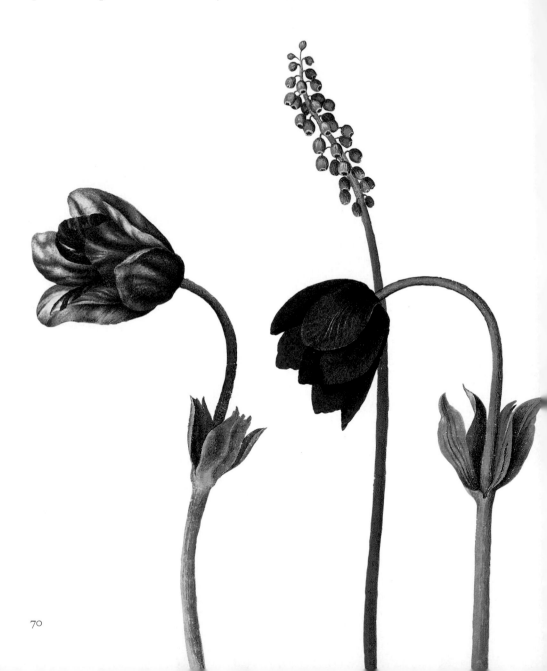

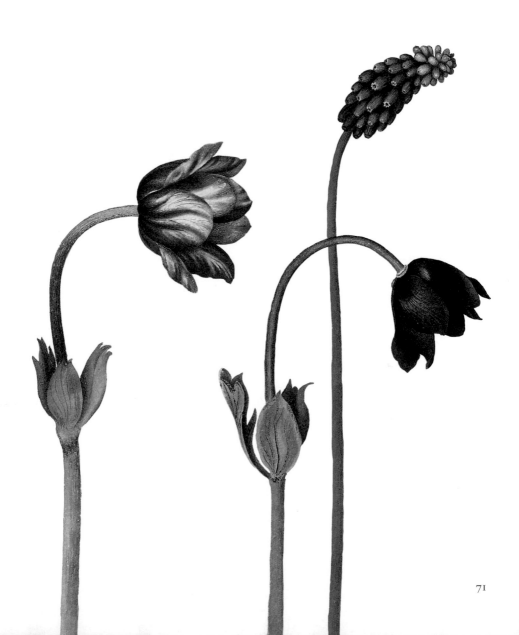

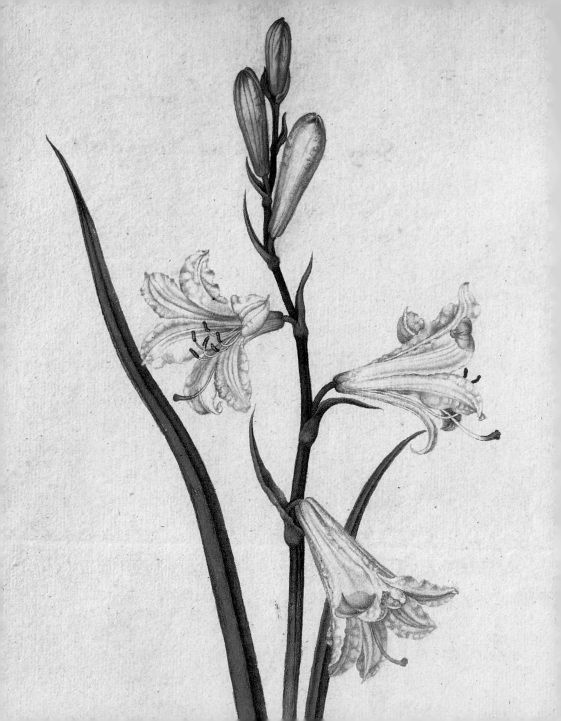

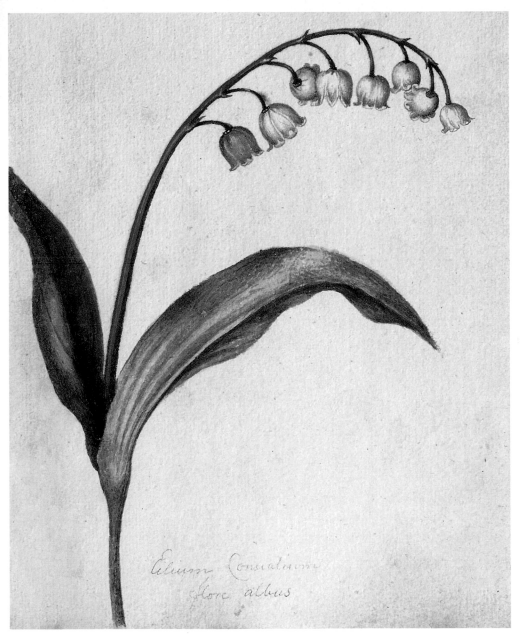

Lilium Convalium
flore albus

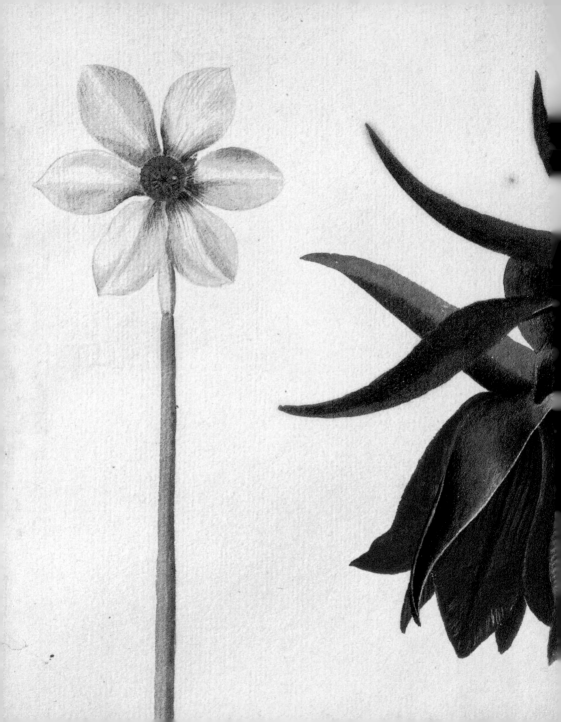

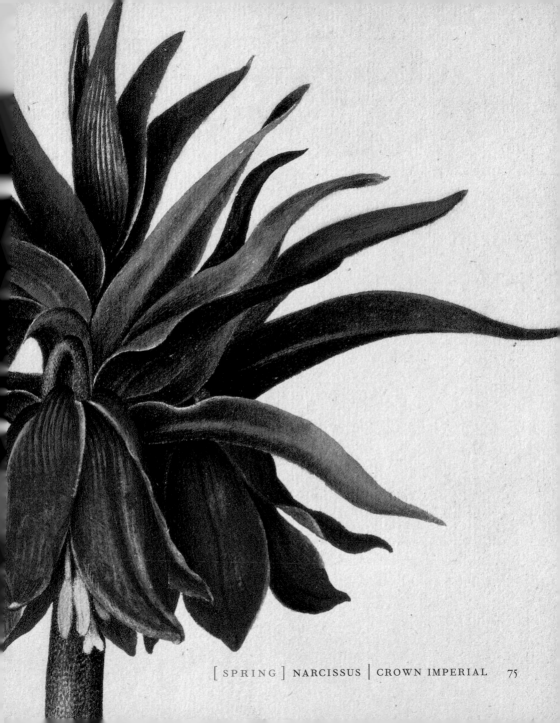

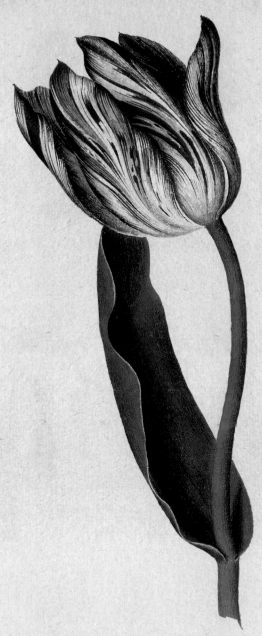
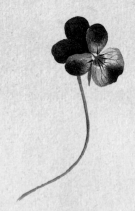

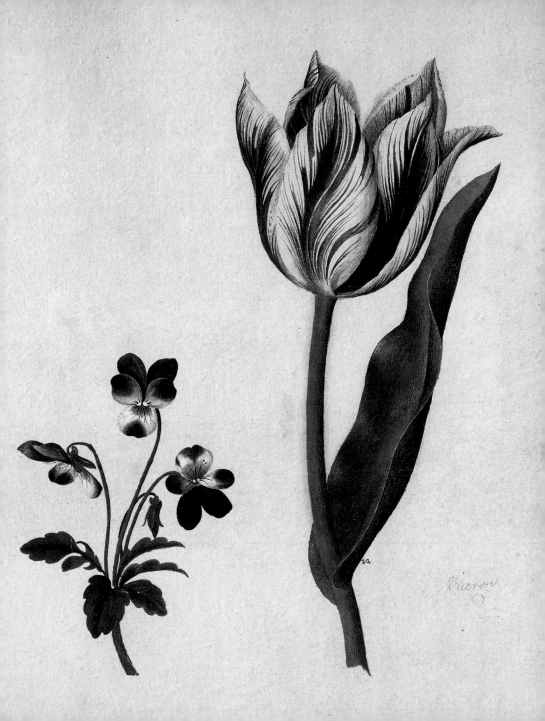

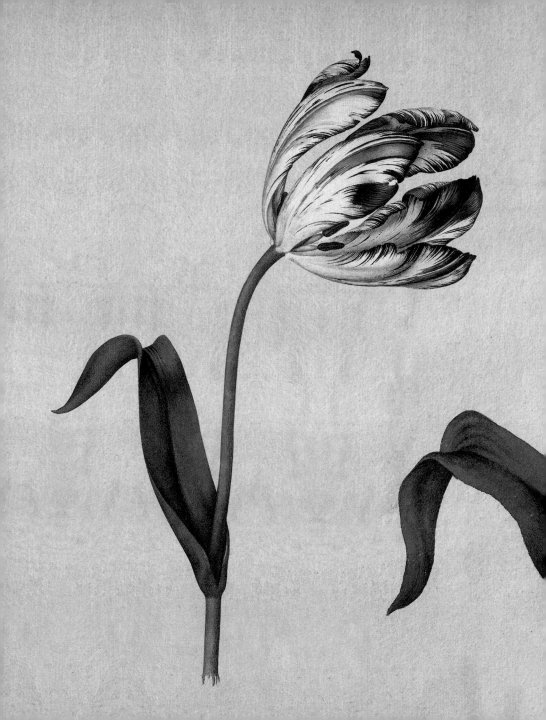

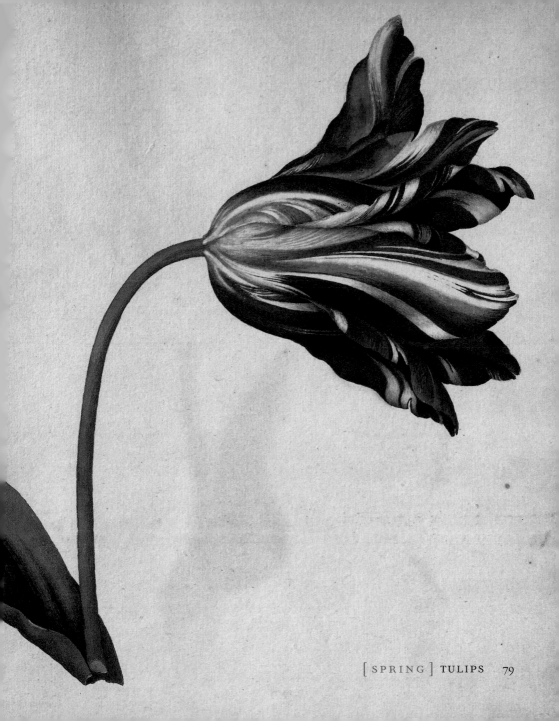

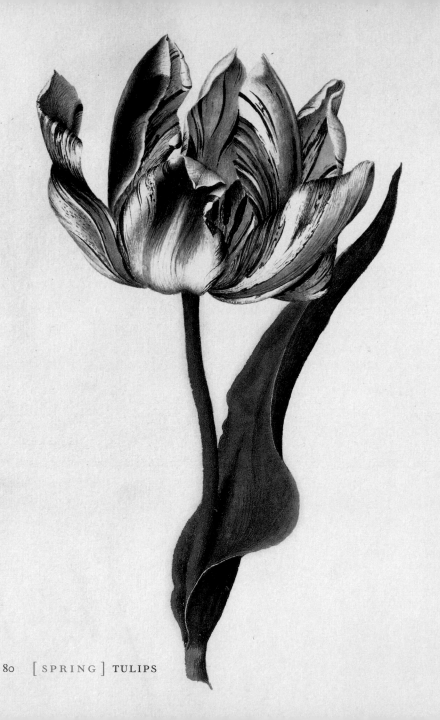

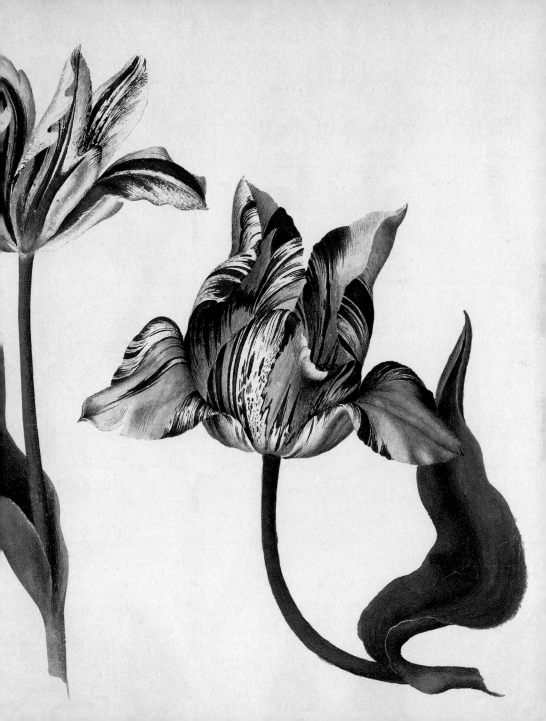

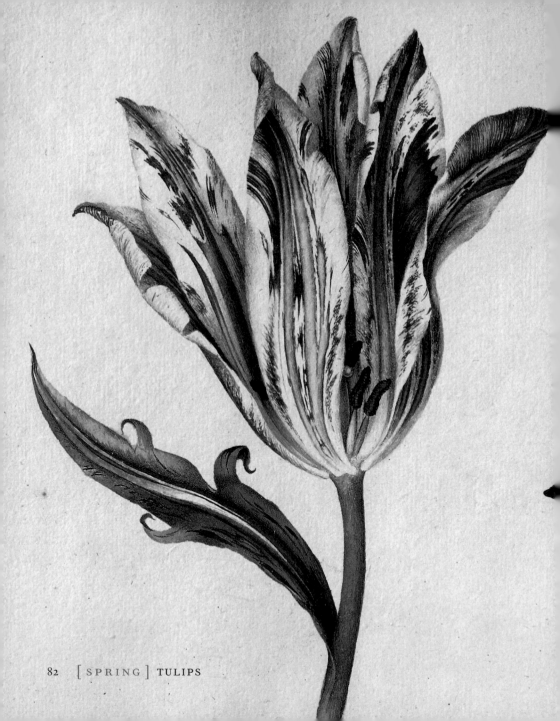

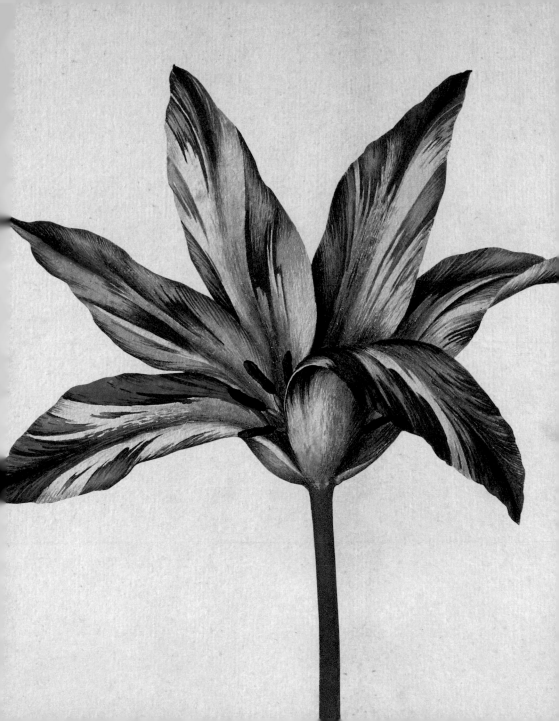

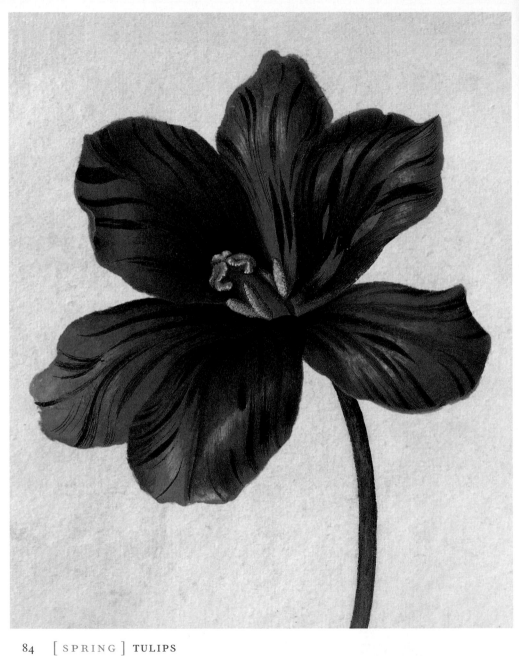

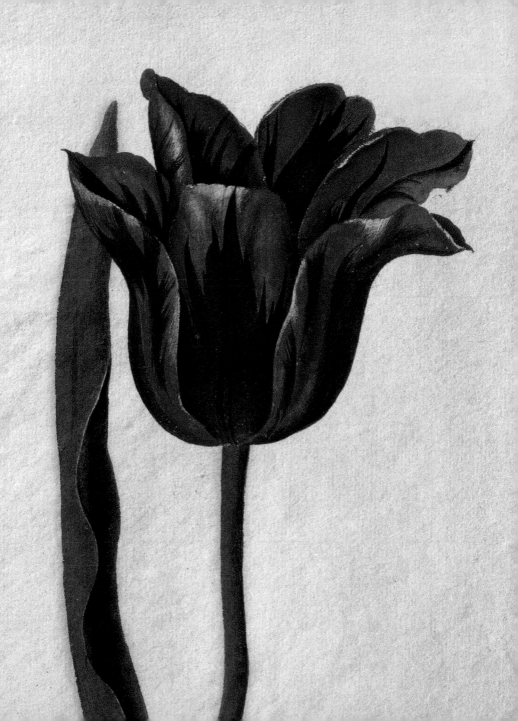

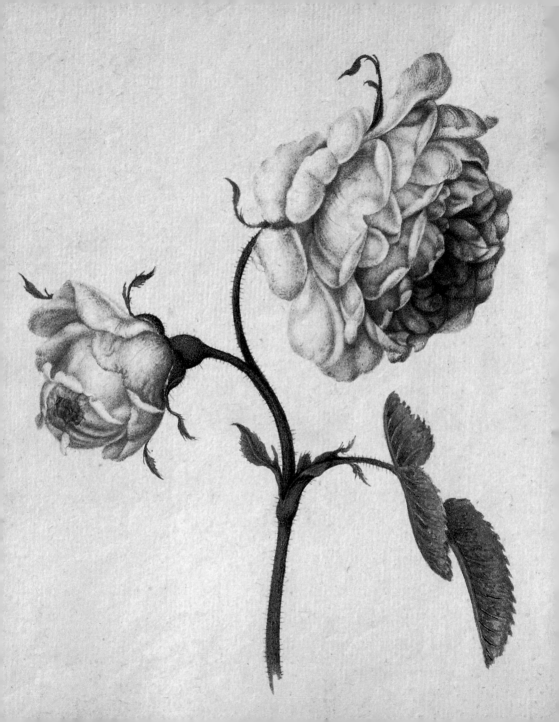

SUMMER

Just as tulips were the stars of the spring for Marshal, summer's roses –
joined by peonies, lilies, carnations and irises – were his favourites. The
forms of irises in particular seem to have fascinated Marshal – the way
the flower rises from its stem, the papery calyx, the contrast between the
shapes of the drooping and upright petals, the flower's markings and in
some species, the beard. The 'mourning iris' (*Iris susiana* L.; page 116)
was noted as being particularly difficult to grow. That illustrated on
page 113, with a hole in one of its petals, is an example of Marshal
recording his specimens as he found them.

Roses and lilies were favourite subjects. The cinnamon rose (opposite) was
another example grown by Gerard in his Holborn garden; the cabbage rose
(page 122) would have been known more poetically in Marshal's time as the
Provence rose, and before that, appropriately, as the 'Hundred-leaved' rose. The
'York and Lancaster rose' (page 121), with its petals of red and white, recalls the
long conflict during the fifteenth century between the rival Yorkists and
Lancastrians for the English crown; the white rose was the symbol for the house
of York, and the red for that of Lancaster.

Lilies were among the most traditional and symbolic of flowers. The Madonna
lily (*Lilium candidum* L.; page 126) had been known in English gardens since
before the Conquest, and is the lily of the Annunciation; Marshal also illustrated

orange lilies, including a double form (page 128). The peony has graced English gardens for just as long a period, and may even be a native plant. Parkinson wrote of how peonies were cherished for 'the beauty and delight of their goodly flowers'.

Carnations were very widely grown in Marshal's time, and were known as both 'gilliflowers' and 'julyflowers', after their flowering season. First cultivated in Moorish Spain in 1460, they too were most esteemed in forms with striped or broken colours. The first specimen in Marshal's *Florilegium* is illustrated on folio 91; further specimens, striped and streaked in every shade of red, pink and purple, appear on more than twenty other sheets and are among Marshal's finest and most delicate drawings.

Amongst these splendid blooms Marshal scatters native summer flowers: columbines, lupins, honeysuckle, hollyhocks, the flowering rush, and poppies. Sweet William, a member of the dianthus family, is now seen as a cottage garden flower and typically English, but it too was an import, albeit an early one – in 1533 they were bought at threepence the bushel for planting in the gardens at Hampton Court.

The sensitive, or 'humble' plant, as it was also known in Marshal's day (*Mimosa pudica* L.; page 130), was recorded by Parkinson as seen 'growing in a pot', just as depicted by Marshal, in the garden of Sir John Danvers in 1639. The Syrian bean caper was grown by Gerard from seeds received from the Low Countries; its pickled flower buds were used as an alternative to capers in flavouring food. A native of the Syrian desert, it is a tough, waxy-leaved shrub, and can be difficult to eradicate.

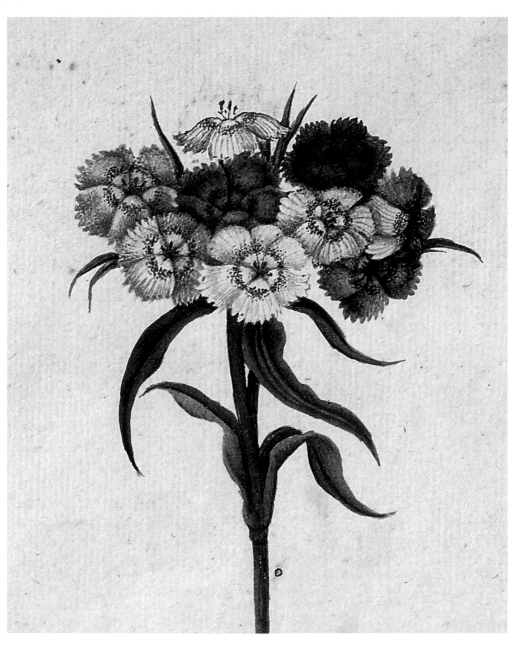

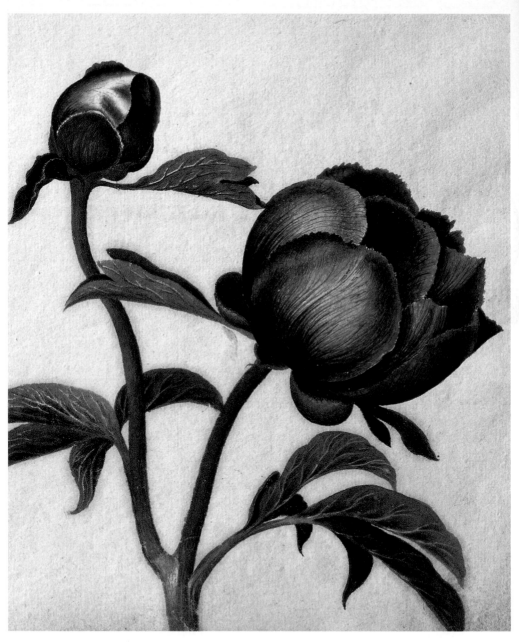

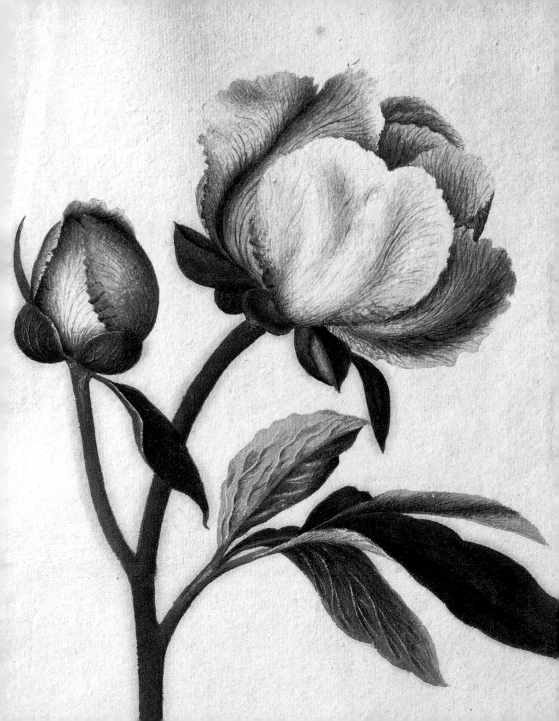

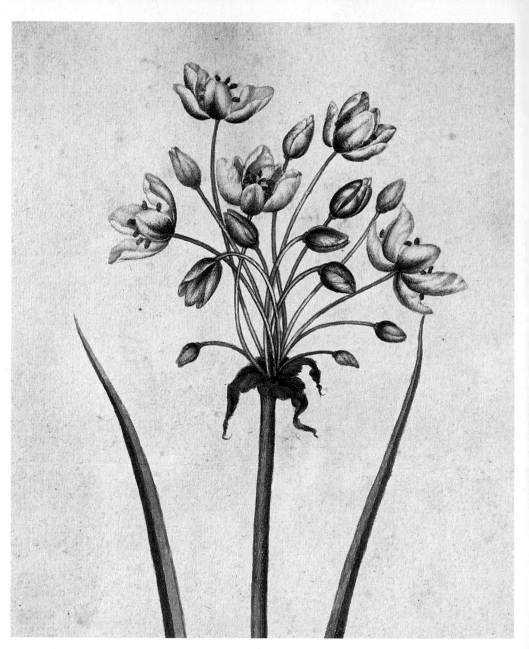

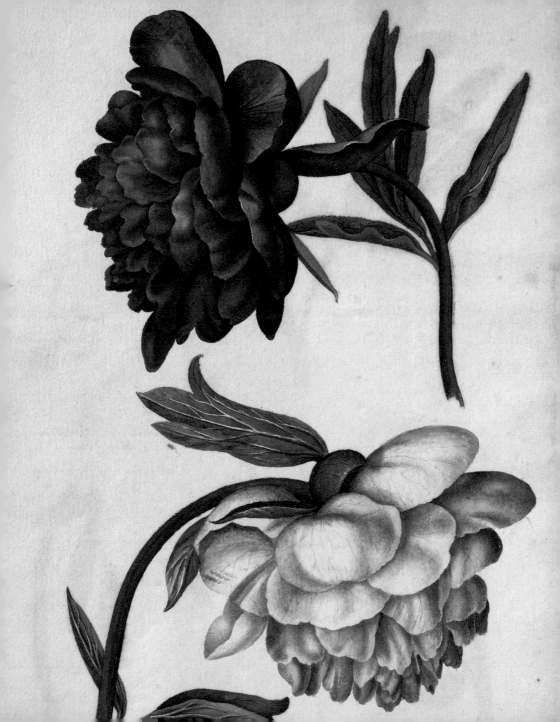

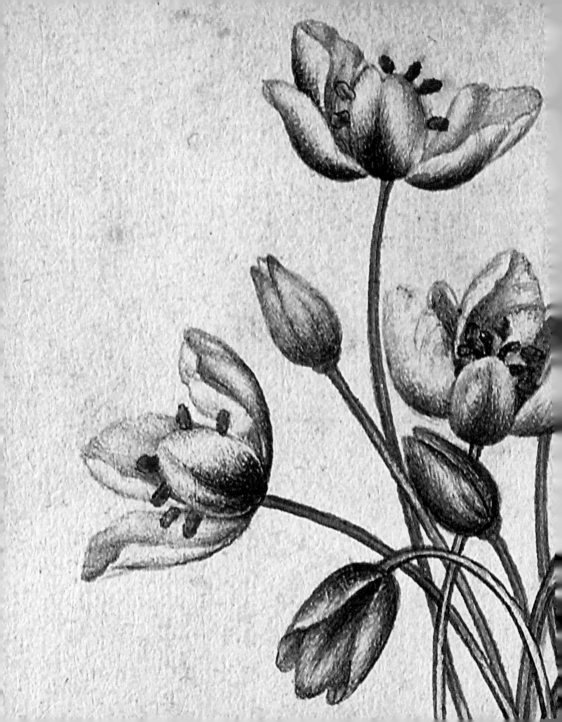

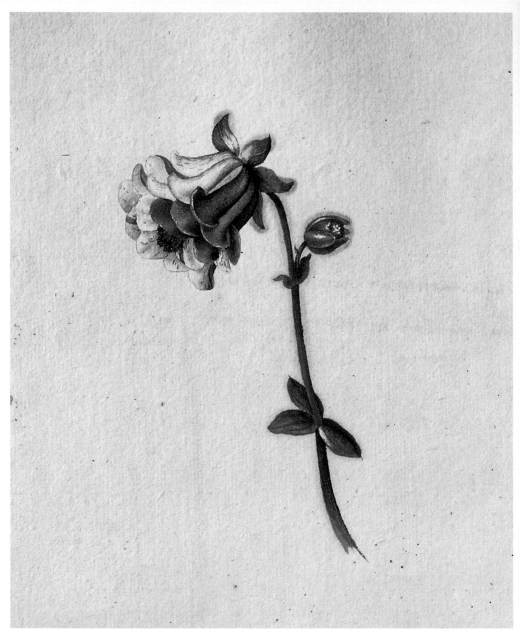

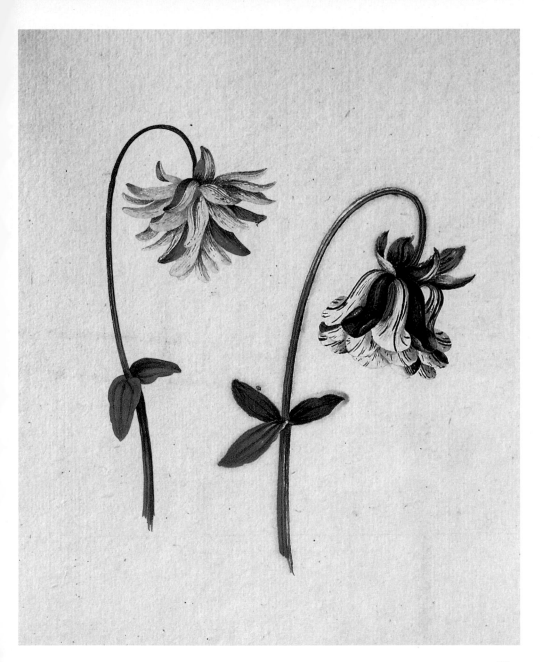

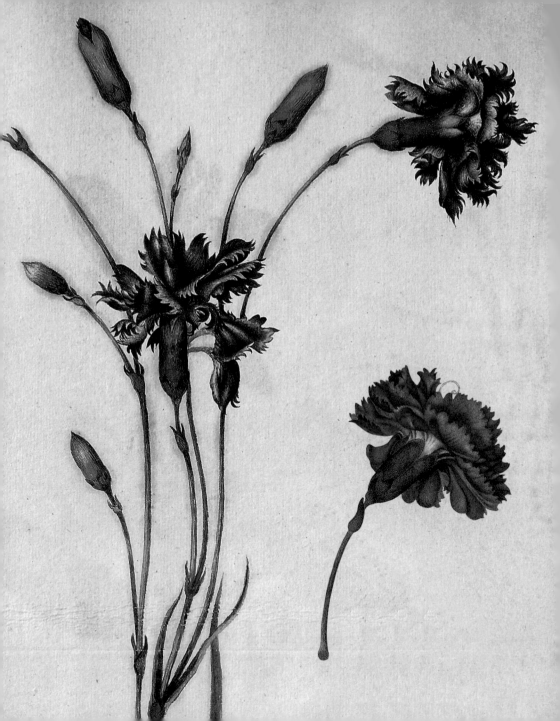

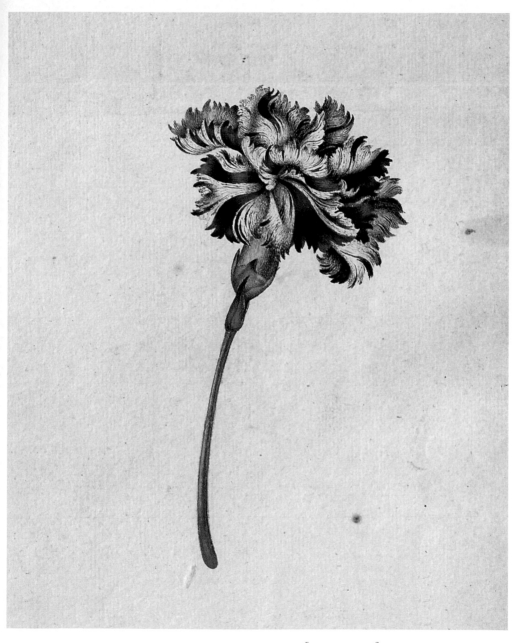

[SUMMER] CARNATION

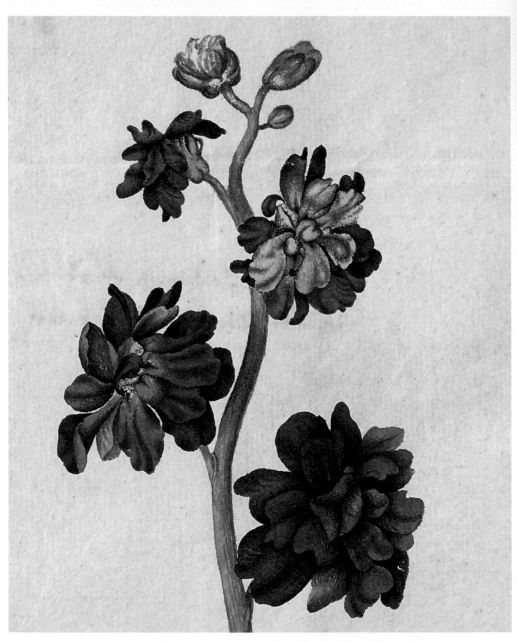

[SUMMER] HOARY STOCK | HOLLYHOCK

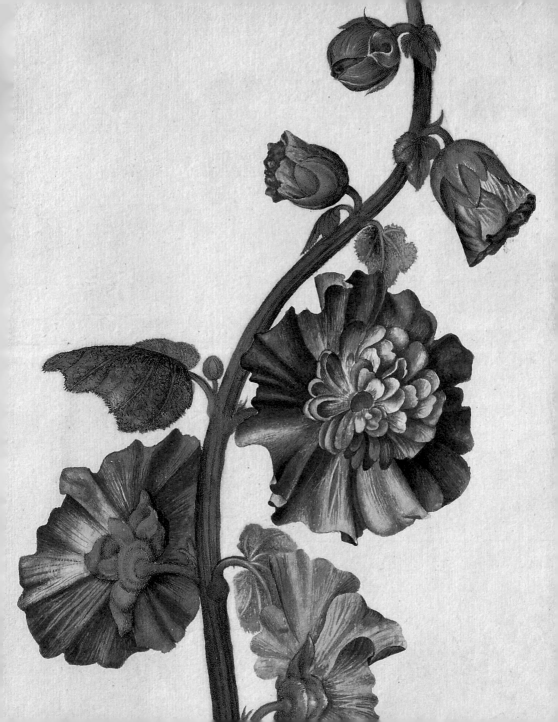

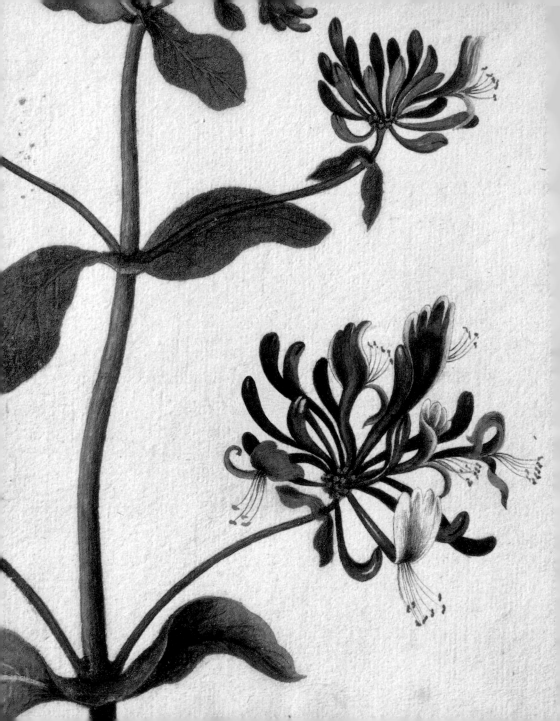

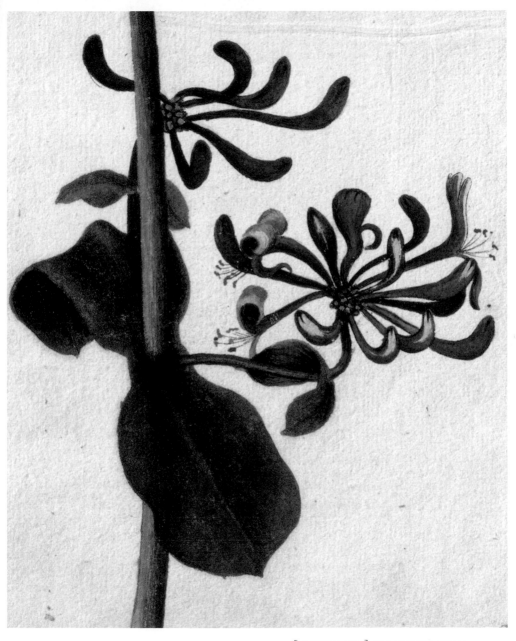

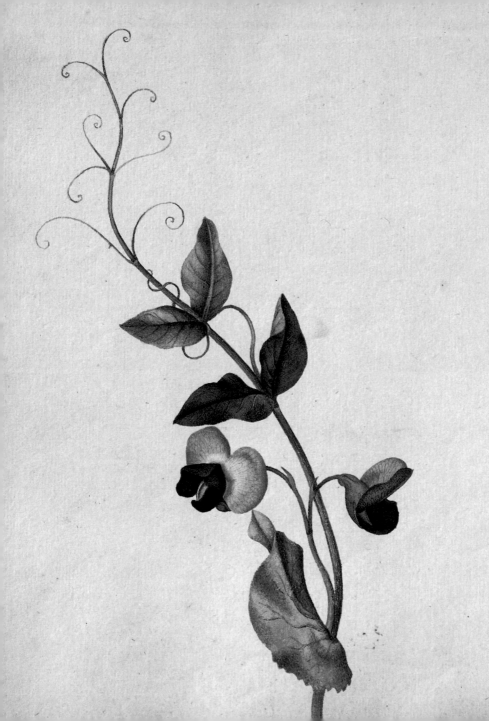

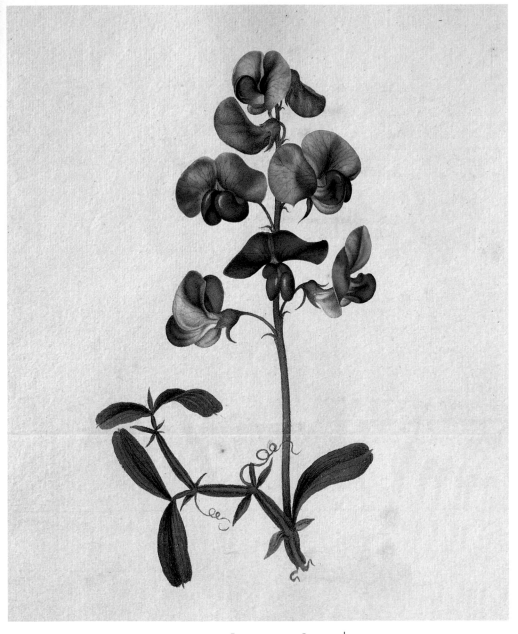

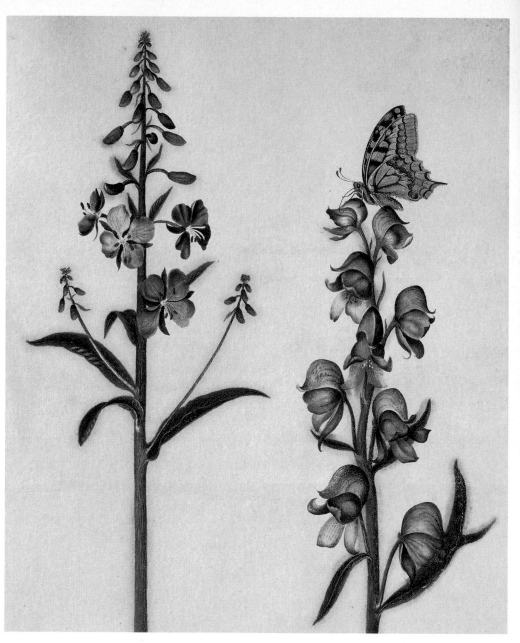

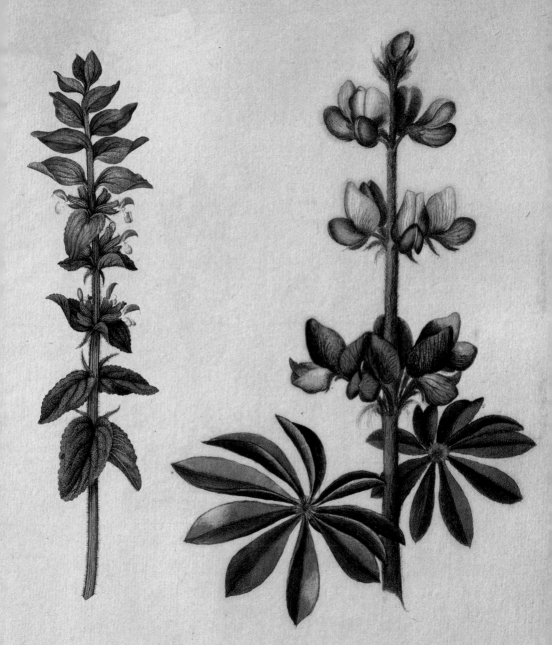

ROSEBAY WILLOW HERB, MONKSHOOD │ PURPLE SAGE, HAIRY LUPIN 109

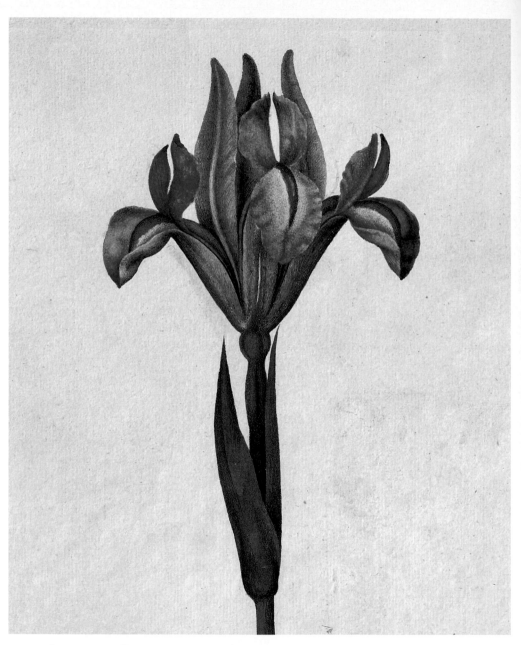

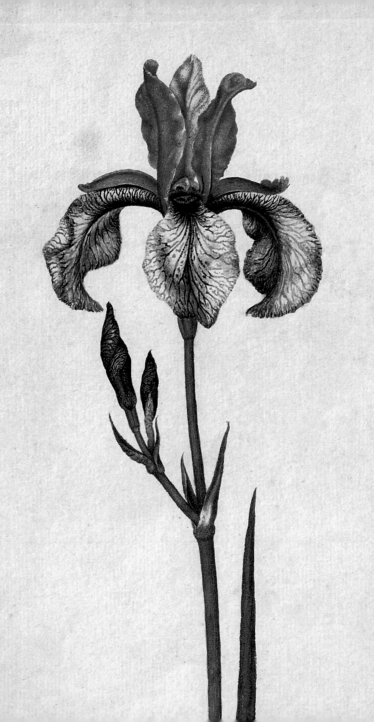

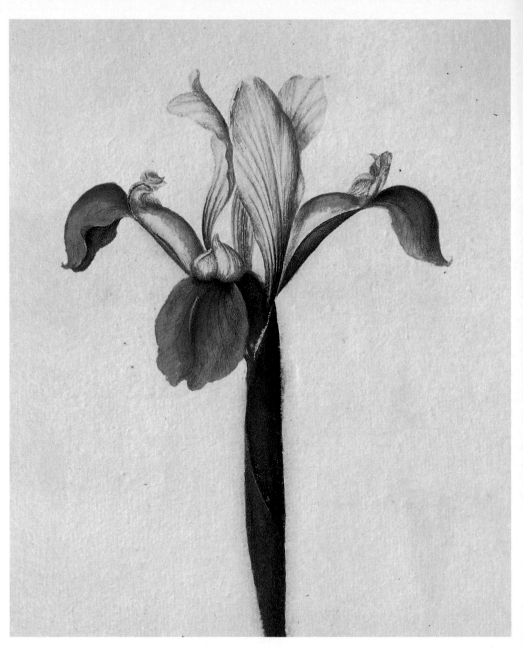

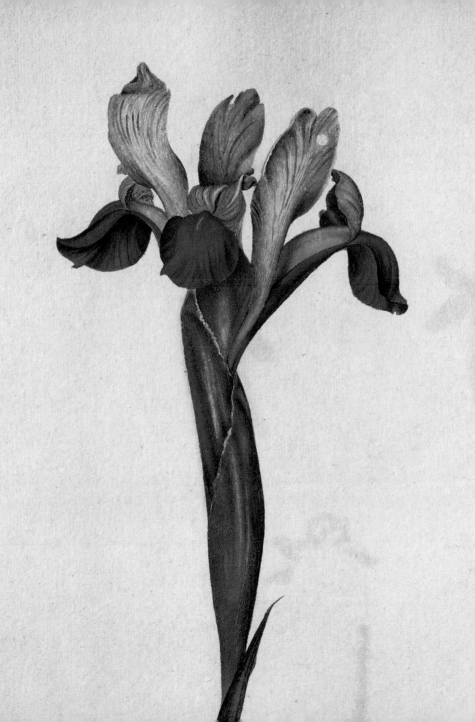

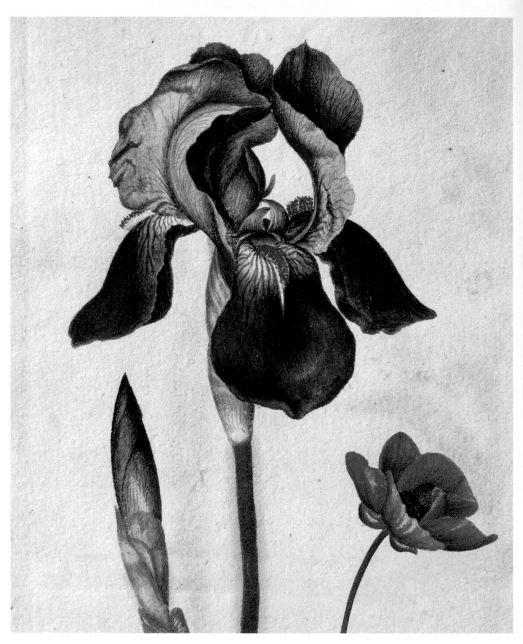

114 [SUMMER] COMMON GERMAN FLAG IRISES, CROWFOOT

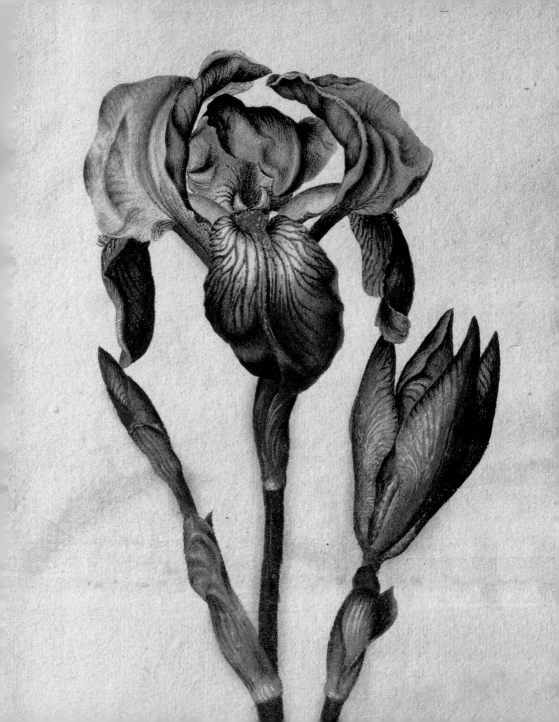

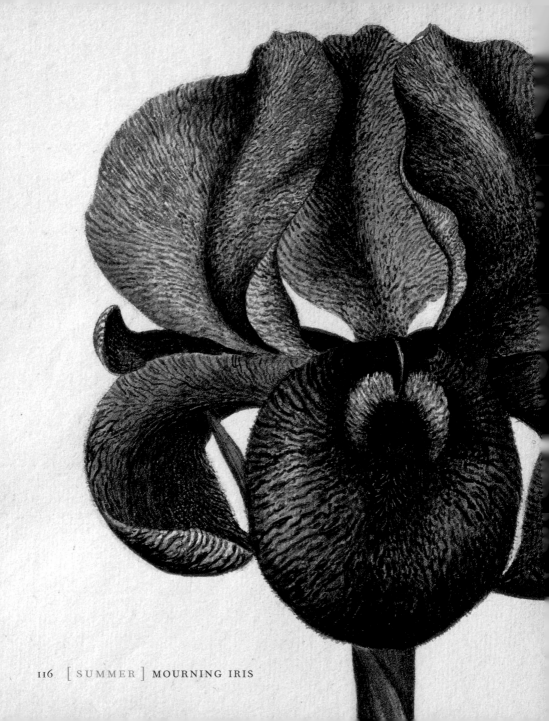

[SUMMER] MOURNING IRIS

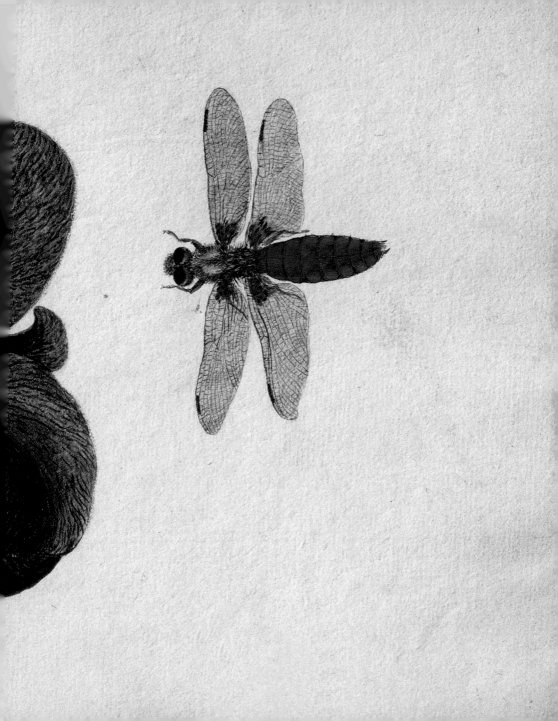

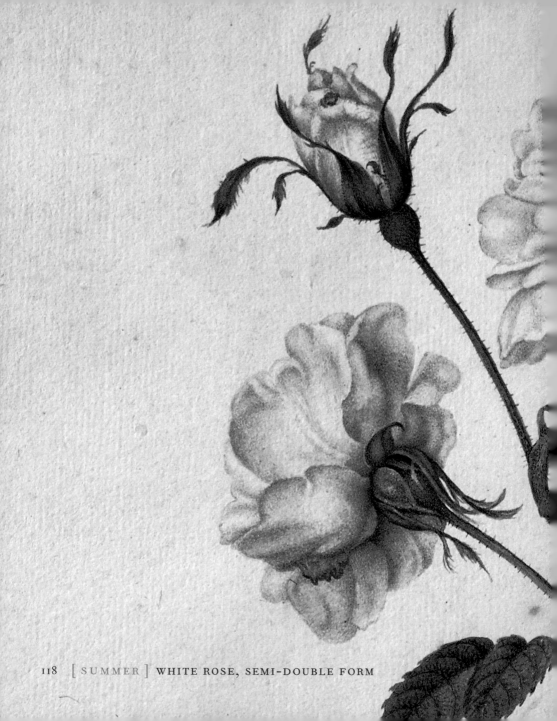

[SUMMER] WHITE ROSE, SEMI-DOUBLE FORM

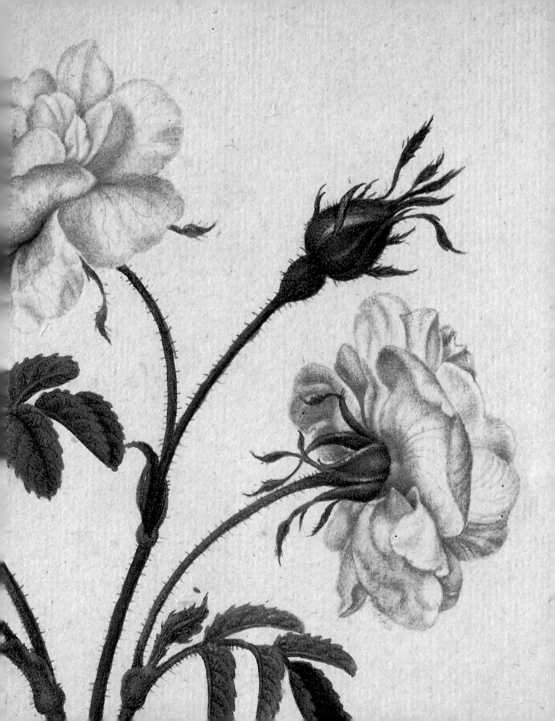

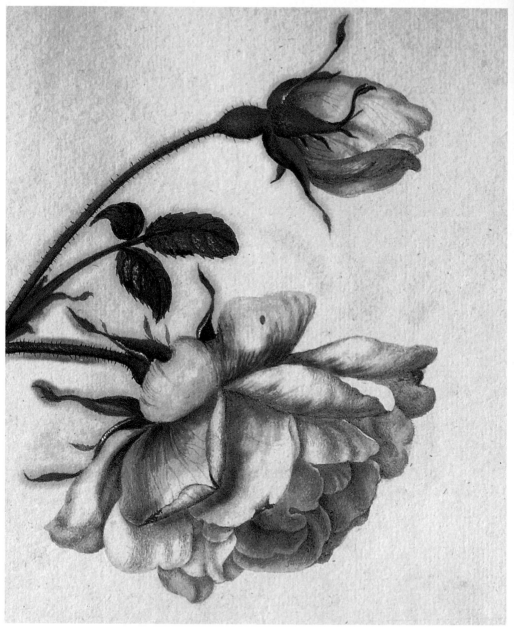

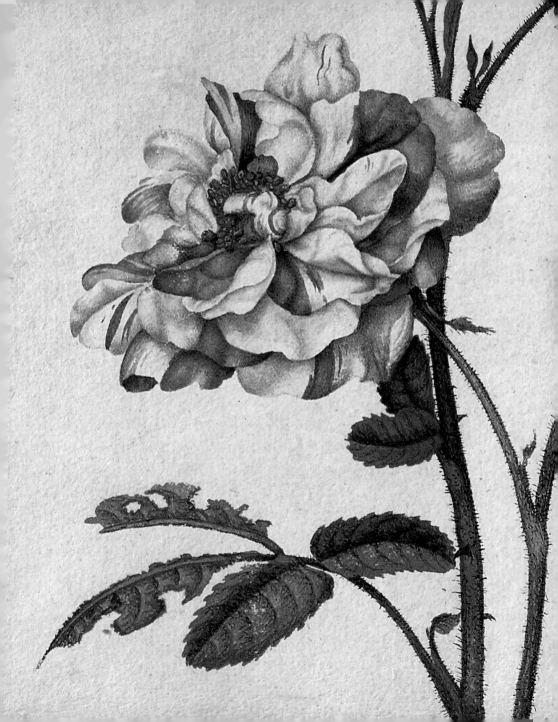

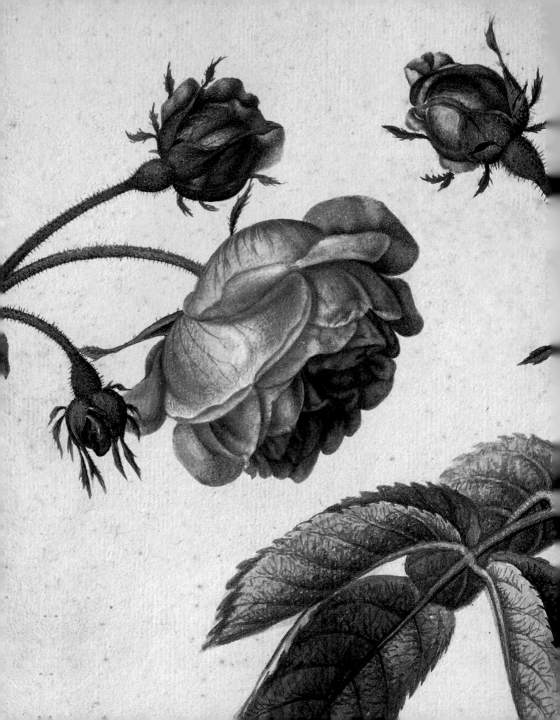

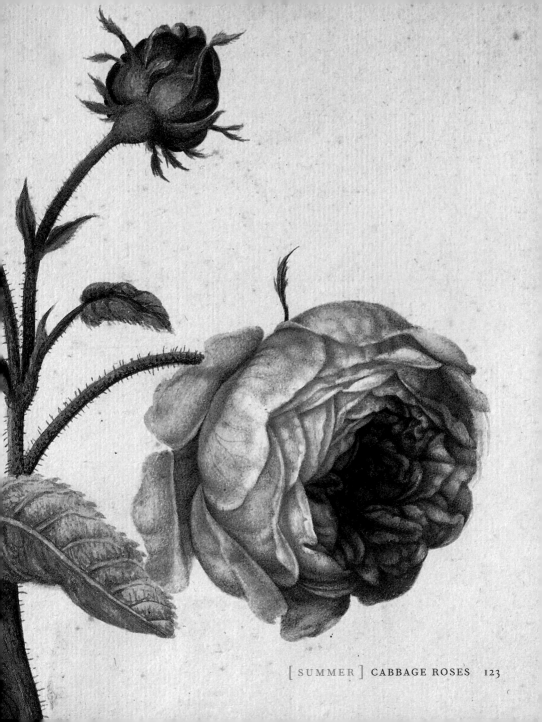

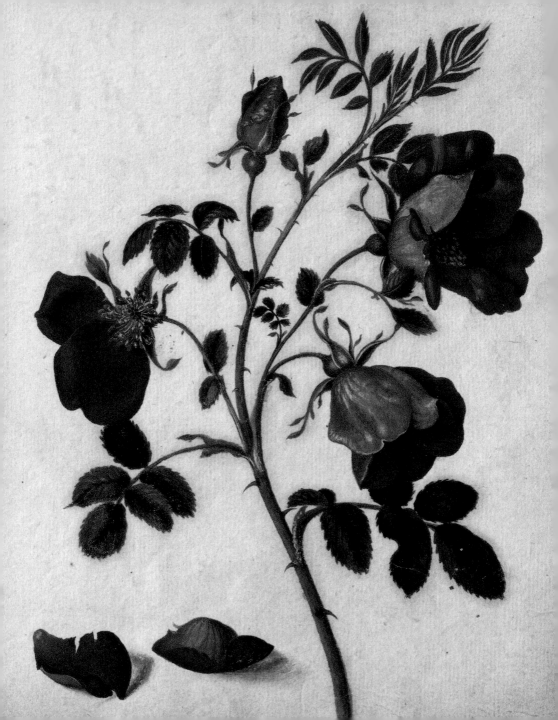

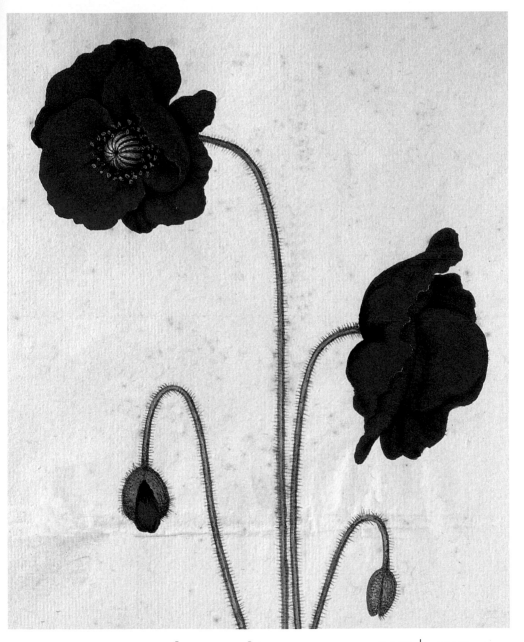

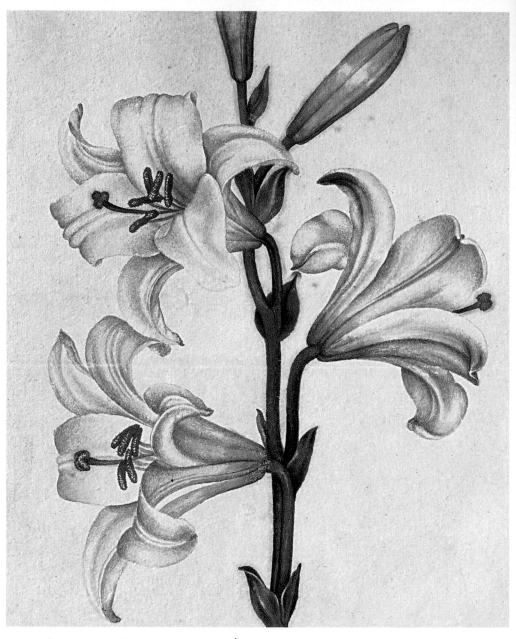

126 [SUMMER] MADONNA LILY │ ORANGE LILY

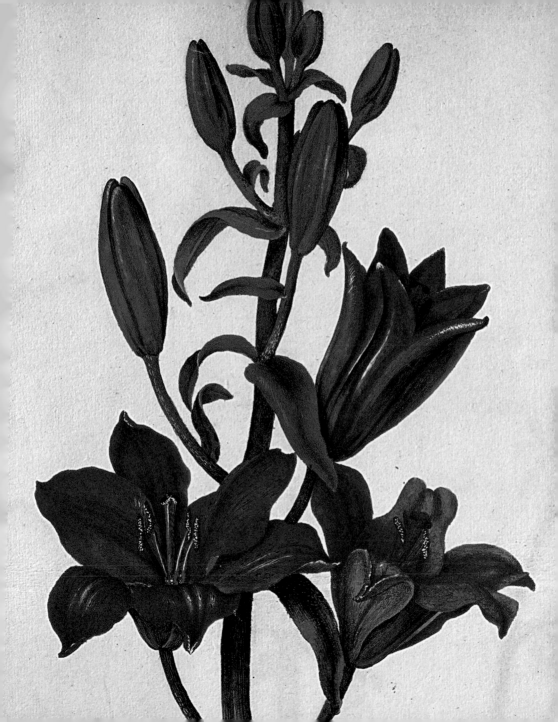

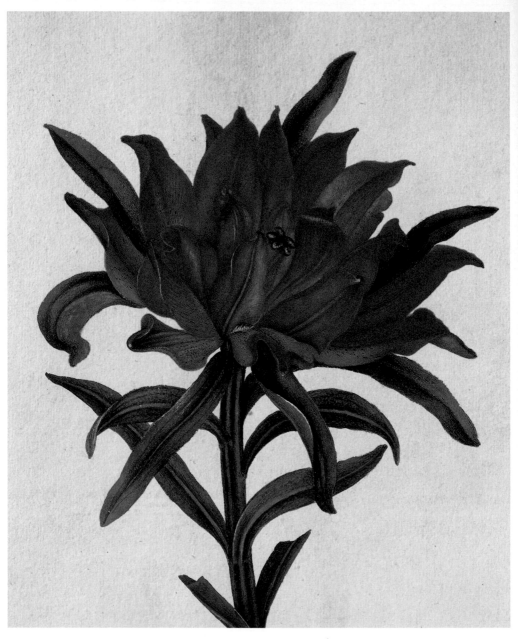

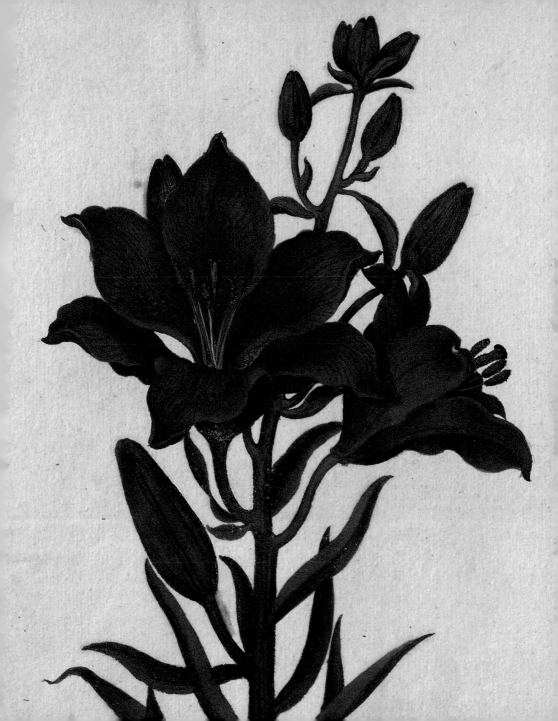

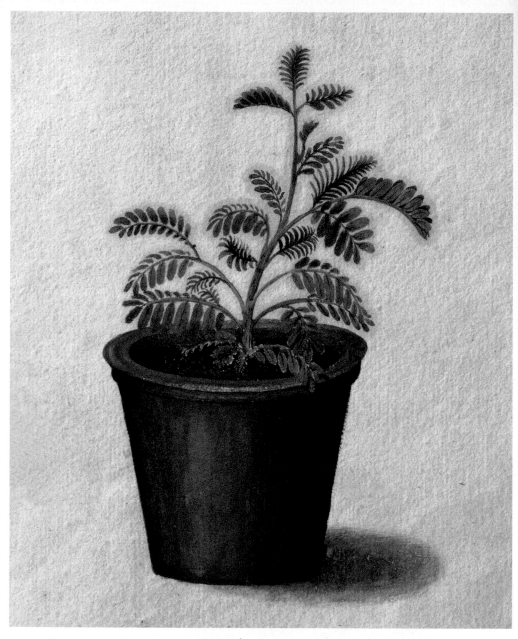

[SUMMER] HUMBLE PLANT | SYRIAN BEAN CAPER

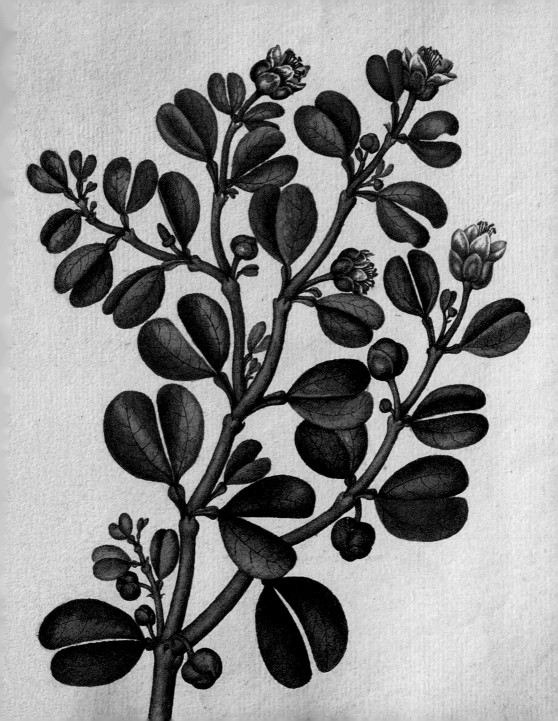

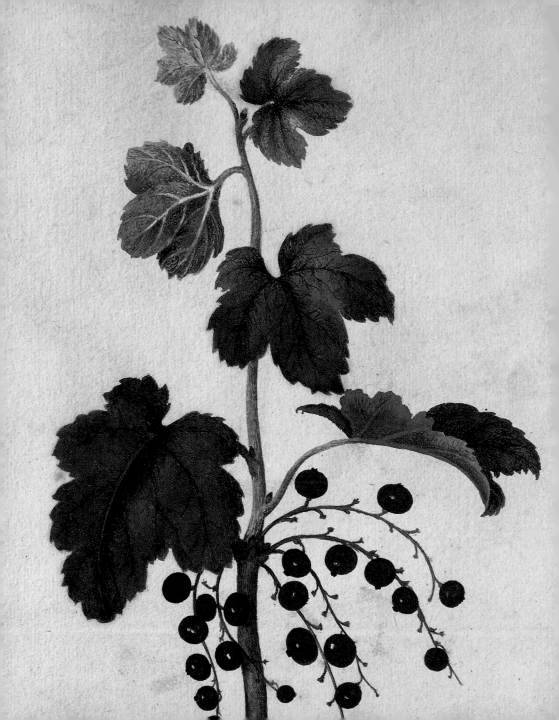

AUTUMN

Autumn in the *Florilegium* features not so much flowers (although Marshal created two glorious studies of sunflowers; see pages 136 and 138) as fruits. Native redcurrants are recorded, together with gooseberries – both red and green varieties were grown in England in Marshal's time. Cherries have been grown in England since the Roman period. The variety 'Archduke', named after the Archduke Albert VII of Austria (1559–1621; Governor of the Spanish Netherlands), is shown on page 134 (left). It was especially prized: John Tradescant the Elder bought a cherry tree of this variety for the gardens at Hatfield House, while Parkinson complained that unscrupulous plantsmen often substituted it with more ordinary varieties – including that bred by John Tradescant the Younger.

Marshal also recorded one of the modern gardener's favourite autumn plants, the Chinese lantern, or winter cherry, as it was known (*Physalis alkakengi* L.; page 135). This was being grown at Syon House, home of the Duke of Somerset, by 1548. Two varieties of pepper are also depicted by Marshal on the same sheet (page 142): a long pepper and a sweet pepper. In the case of the latter, it was well recognised that the fruit needed a good summer to ripen properly – 'we expect better when God shall sende us a hot and temperate yeere', wrote Gerard in 1597, after what seems to have been a disappointing crop, echoing the patient optimism

required of gardeners down the ages. Also on this sheet is the 'trew figure' of ginger, from Bishop Compton's garden at Fulham Palace. One wonders if the hot flavour of ginger root prompted Marshal to group it and the two pepper varieties together.

The black mulberry (page 148), the 'muray' plum ('murray' describes its dark purple colour) and the bullace (page 149) were also very well-known plants in Marshal's day. The balloon pea (*Sutherlandia frutescens* [L.] R. Br.; page 140) was significantly more unusual: Marshal's drawing may represent the first-ever illustration of this plant, and it was so recent an introduction that he had to leave it unnamed. The plant in fact originates in South Africa, and was named by James Sutherland of the Edinburgh Botanic Garden in 1683.

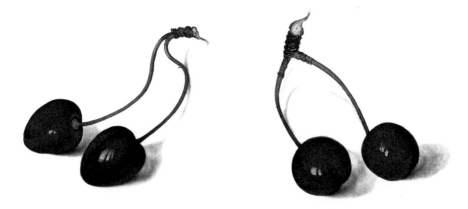

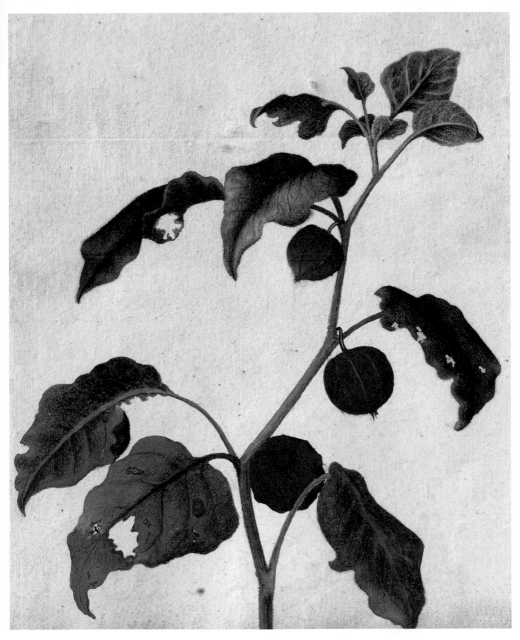

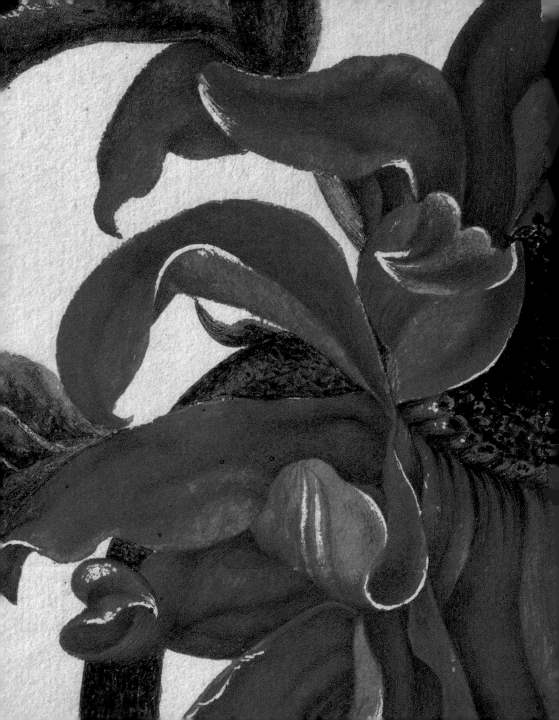

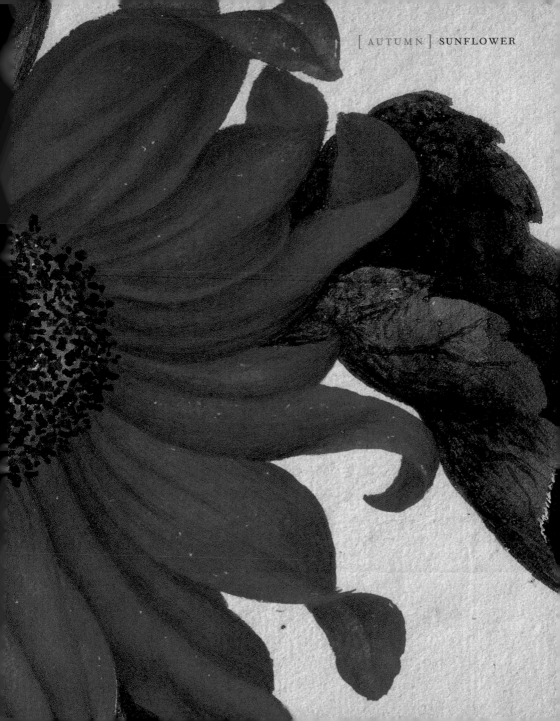

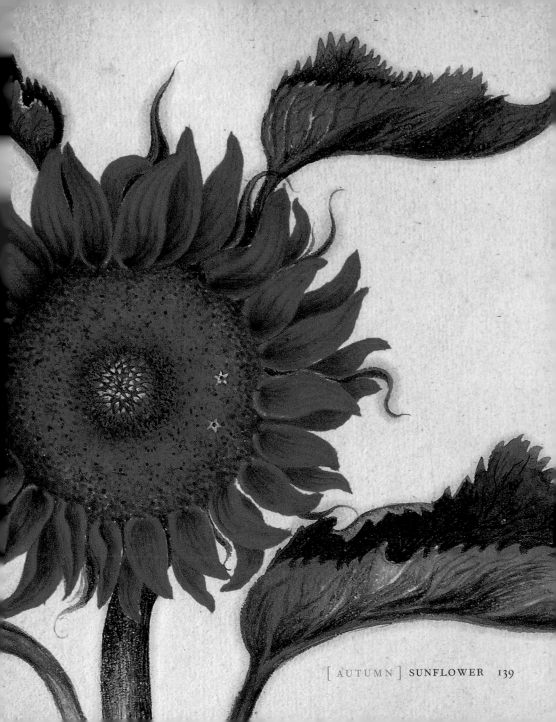

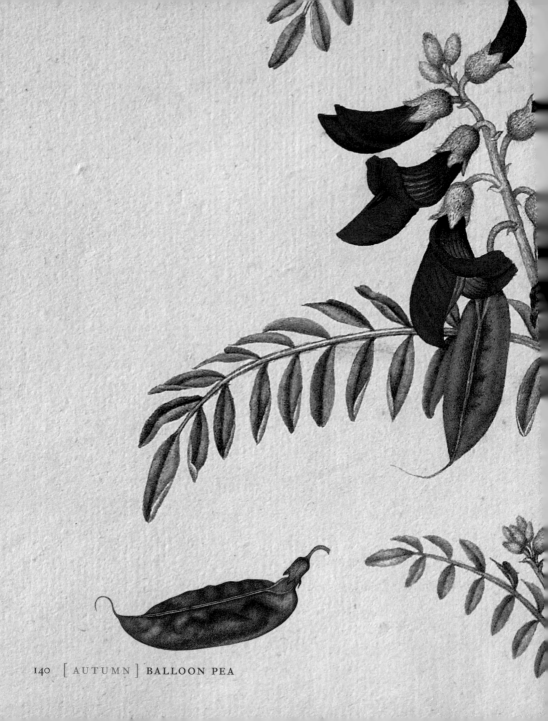

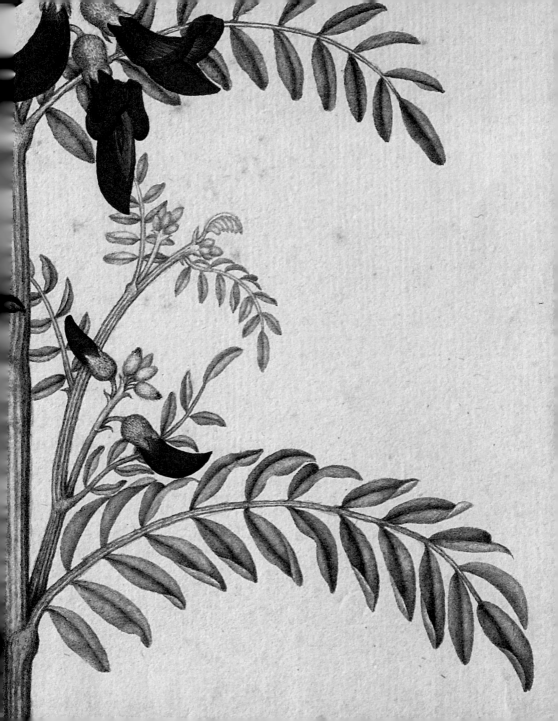

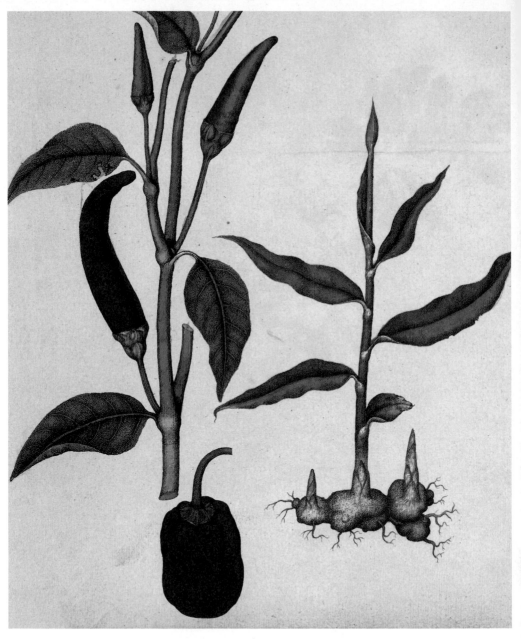

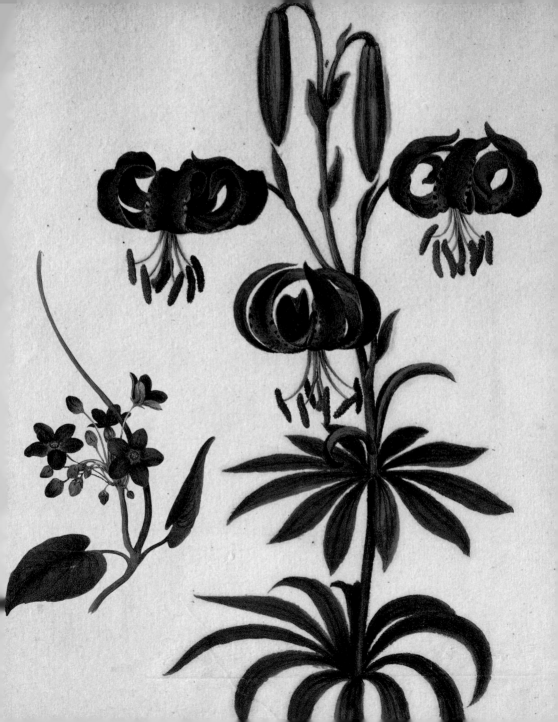

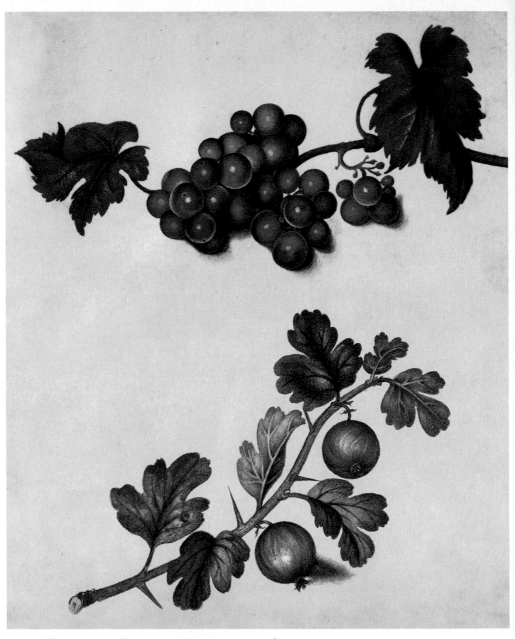

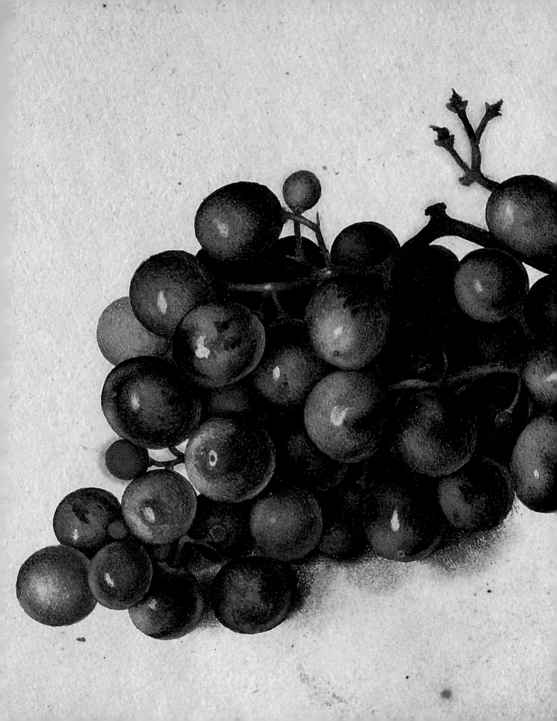

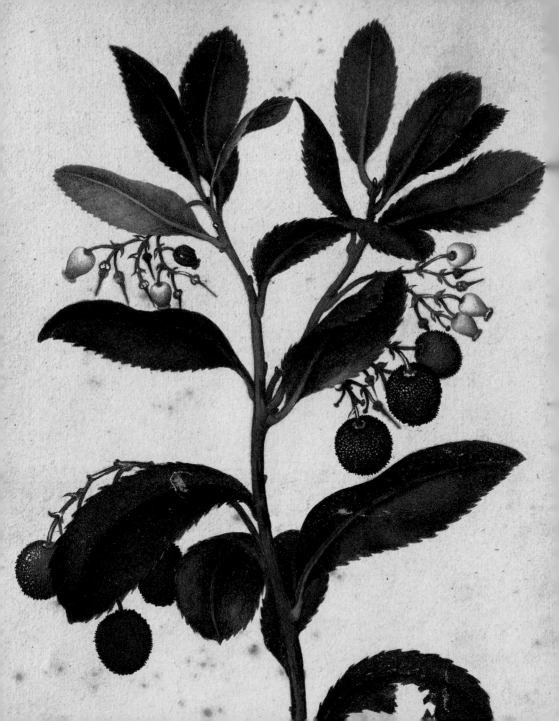

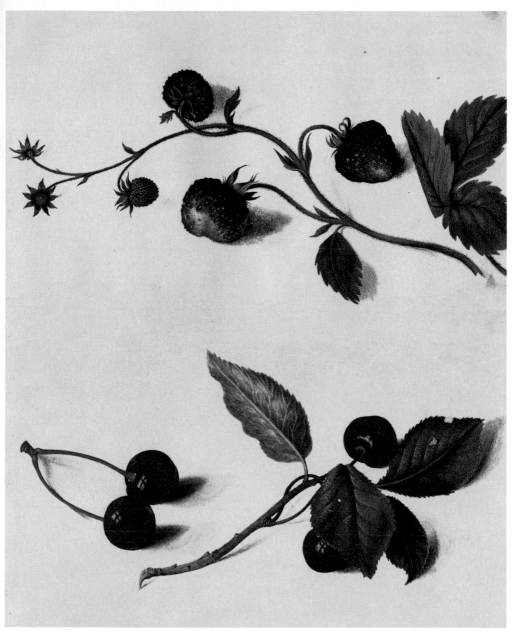

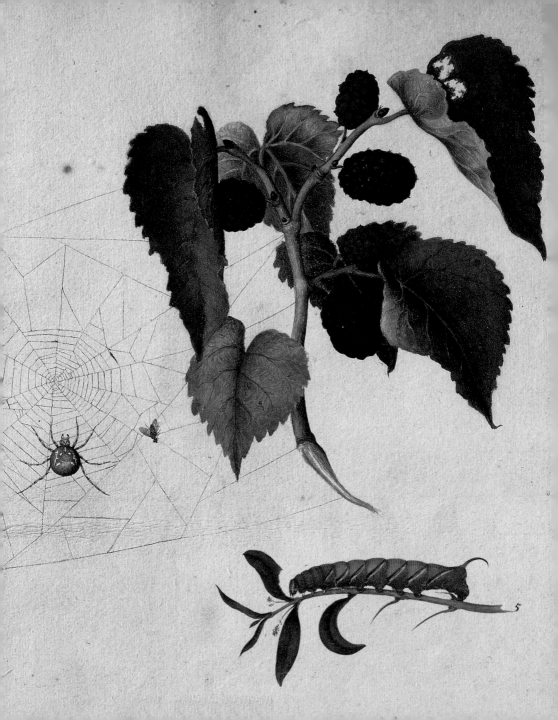

5

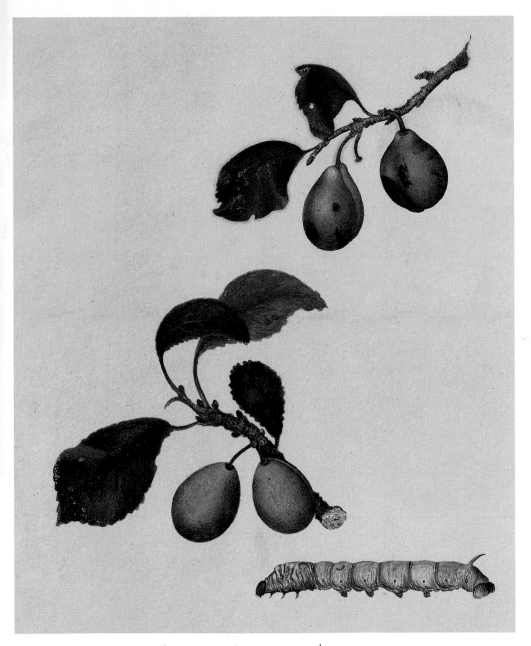

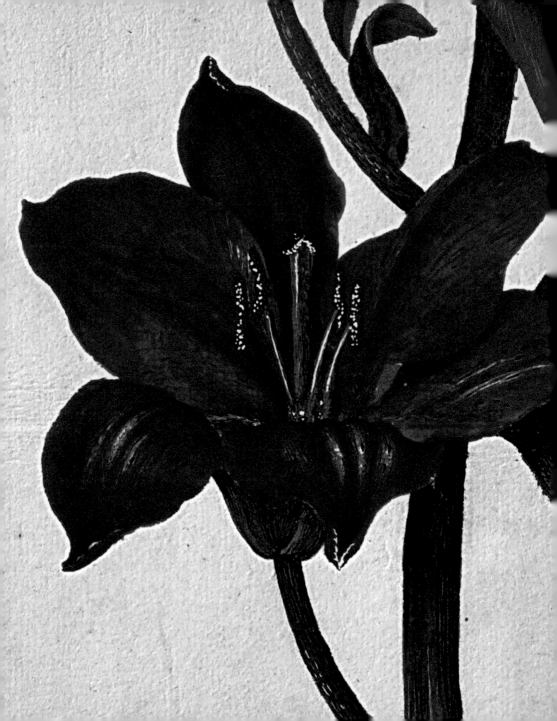

ORIGINAL PLATES

from the *Florilegium* of
Alexander Marshal

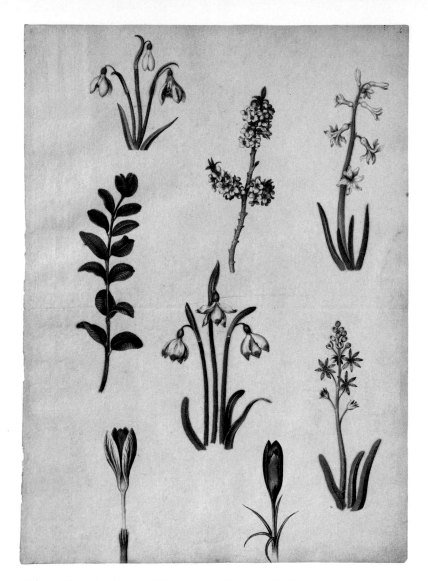

Folio 4 Clockwise from top left: snowdrop (*Galanthus nivalis* L.); mezereon (*Daphne mezereum* L.); hyacinth (*Hyacinthus orientalis* L.); spring squill (*Scilla verna* Hudson); purple crocus (*Crocus vernus* Hill); spring snowflake (*Leucojum vernum* L.); purple crocus, form (*Crocus vernus* Hill [form]); margined box (*Buxus sempervirens* L. 'Marginata'). (RL 24271)

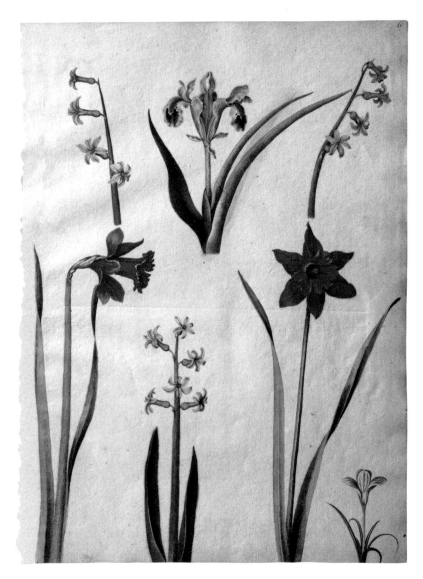

Folio 6 Clockwise from top left: hyacinth (*Hyacinthus orientalis* L.); Persian iris (*Iris persica* L.); hyacinth (*Hyacinthus orientalis* L.); purple crocus (*Crocus vernus* Hill); Spanish daffodil (*Narcissus hispanicus* Gouan); hyacinth (*Hyacinthus orientalis* L.); Spanish daffodil (*Narcissus hispanicus* Gouan). (RL 24273)

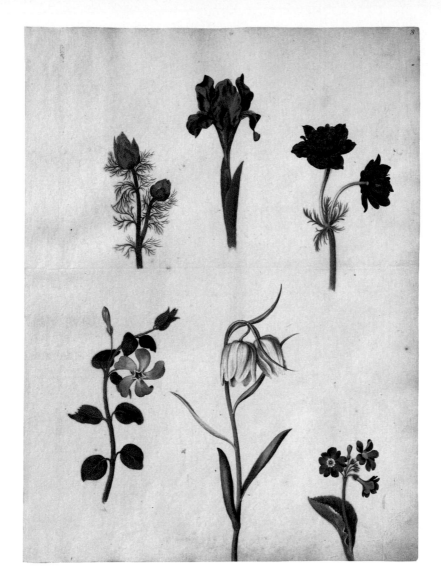

Folio 8 Clockwise from top left: ox-eye (*Adonis vernalis* L.); dwarf bearded iris or pygmy iris (*Iris pumila* L.); poppy anemone (*Anemone coronaria* L.); auricula (*Primula* x *pubescens* Jacq.); snake's-head fritillary, white form (*Fritillaria meleagris* L. *alba*); greater periwinkle (*Vinca major* L.). (RL 24275)

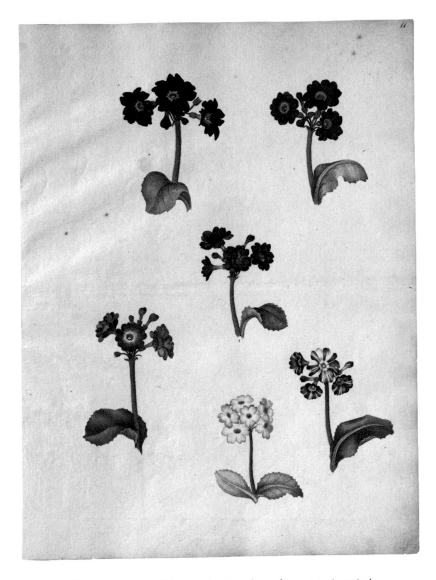

Folio 11 Clockwise from top left: auricula (*Primula* x *pubescens* Jacq.); auricula
(*Primula* x *pubescens* Jacq.); auricula, double form (*Primula* x *pubescens* Jacq. 'Flore
Pleno'); auricula (*Primula* x *pubescens* Jacq.); auricula (*Primula* x *pubescens* Jacq.);
auricula (*Primula* x *pubescens* Jacq.). (RL 24278)

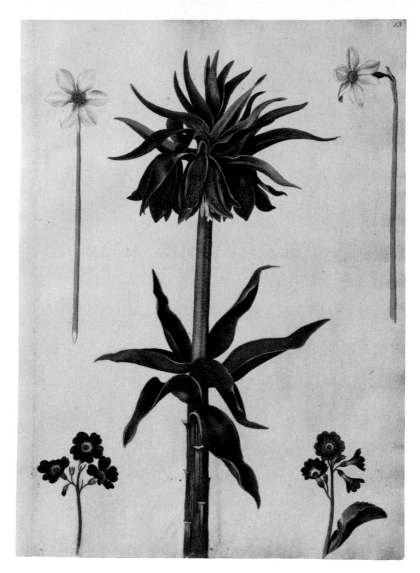

Folio 13 Clockwise from top left: narcissus (literally ray-flowered; *Narcissus radiiflorus* Pugsley); crown imperial (*Fritillaria imperialis* L.); poet's narcissus (*Narcissus poeticus* L.); auricula (*Primula* x *pubescens* Jacq.); auricula (*Primula* x *pubescens* Jacq.). (RL 24280)

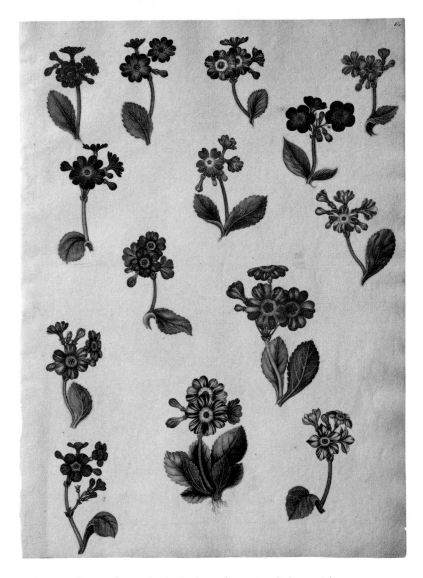

Folio 14 Full page of auriculas (*Primula* x *pubescens* Jacq.). (RL 24281)

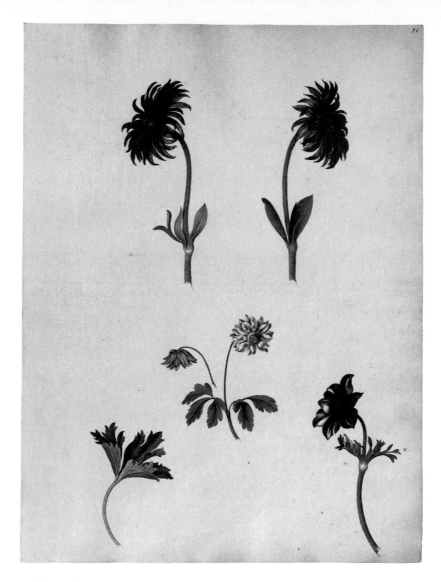

Folio 21 Clockwise from top left: star anemone, double form (*Anemone pavonina* Lam. *plena*); star anemone, double form (*Anemone pavonina* Lam. *plena*); star anemone (*Anemone pavonina* Lam.); wood anemone, double purple form (*Anemone nemorosa* L. *purpurea* 'Flore Pleno'); leaf of star anemone (*Anemone pavonina* Lam.). (RL 24288)

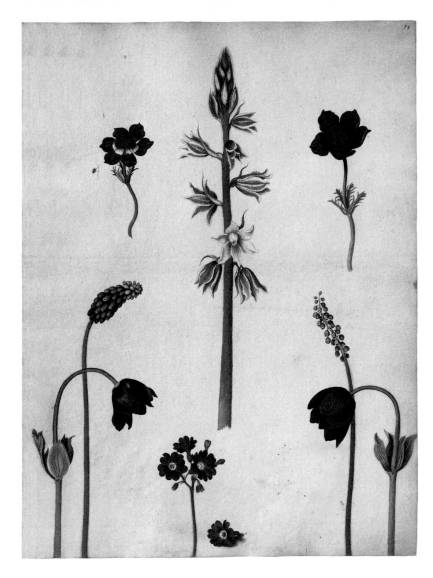

Folio 28 Clockwise from top left: poppy anemone (*Anemone coronaria* L.); drooping star of Bethlehem (*Ornithogalum nutans* L.); poppy anemone (*Anemone coronaria* L.); star anemone (*Anemone pavonina* Lam.); small grape hyacinth (*Muscari botryoides* [L.] Miller); auricula (*Primula* x *pubescens* Jacq.); grape hyacinth (*Muscari neglectum* Guss.); star anemone (*Anemone pavonina* Lam.). (RL 24295)

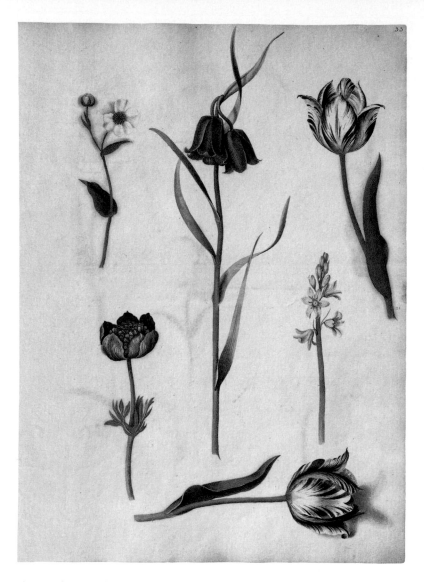

Folio 33 Clockwise from top left: tuberous meadow rue (*Thalictrum tuberosum* L.);
Pyrenean fritillary (*Fritillaria pyrenaica* L.); tulip (*Tulipa gesneriana* L. cv.); Spanish
bluebell (*Hyacinthoides hispanica* L.); tulip (*Tulipa gesneriana* L. cv.); star anemone
(*Anemone pavonina* Lam.). (RL 24300)

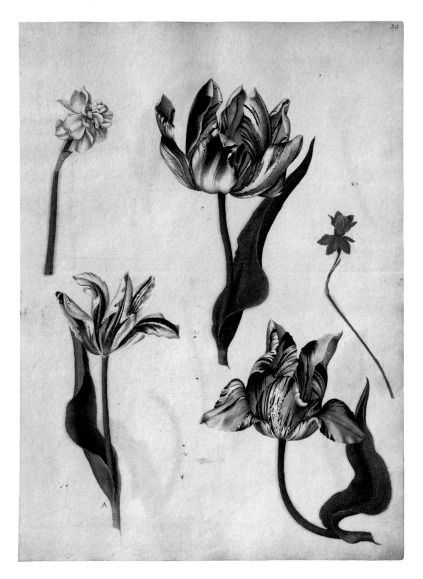

Folio 35 Clockwise from top left: poet's narcissus, double form (*Narcissus poeticus* L. 'Plenus'); tulip (*Tulipa gesneriana* L. cv.); jonquil, abnormal double form (*Narcissus jonquilla* L. abnormal double); tulip (*Tulipa gesneriana* L. cv.); tulip (*Tulipa gesneriana* L. cv.). (RL 24302)

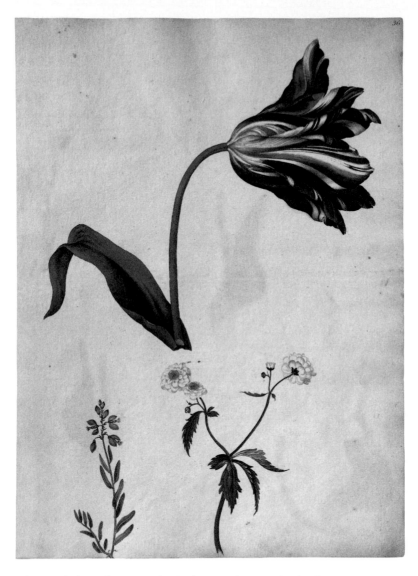

Folio 36 Clockwise from top: tulip (*Tulipa gesneriana* L. cv.); white buttercup, double cultivar (*Ranunculus aconitifolius* L. 'Pleniflorus'); common milkwort (*Polygala vulgaris* L.). (RL 24303)

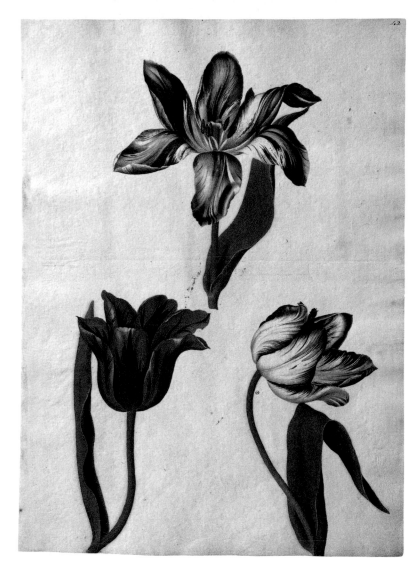

Folio 42 Full page of tulips (*Tulipa gesneriana* L. cv.). (RL 24309)

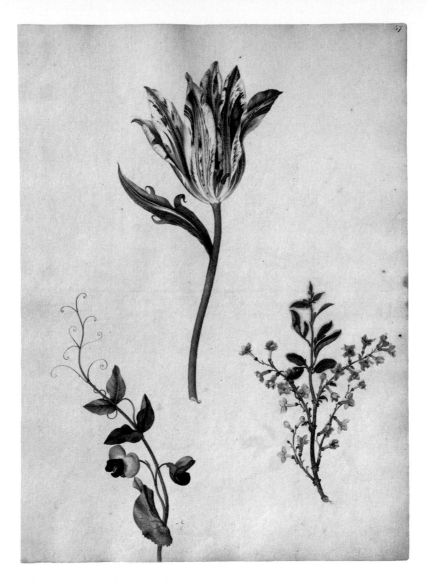

Folio 47 Clockwise from top: tulip (*Tulipa gesneriana* L. cv.); Persian lilac (*Syringa* x *persica* L.); pea (*Pisum sativum* L.). (RL 24314)

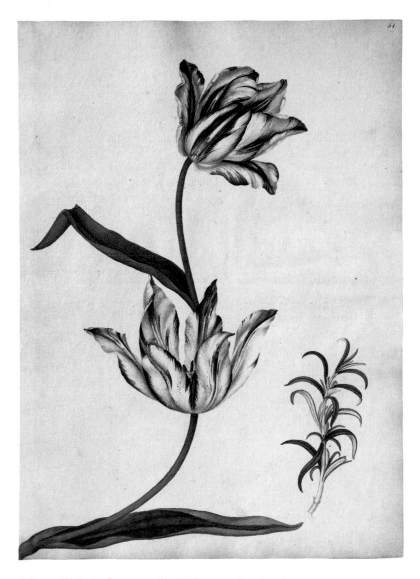

Folio 51 Clockwise from top: tulip (*Tulipa gesneriana* L. cv.); rosemary (*Rosmarinus officinalis* L.); tulip (*Tulipa gesneriana* L. cv.). (RL 24318)

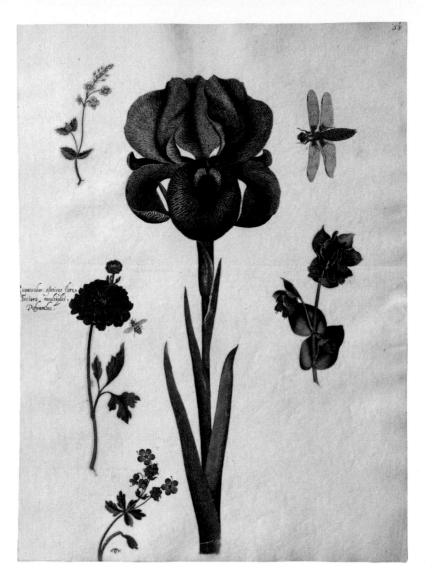

58

Folio 58 Clockwise from top: germander speedwell (*Veronica chamaedrys* L.);
mourning iris (*Iris susiana* L.); female broad-tailed chaser dragonfly or broad-bodied
libellula (*Libellula depressa*); honeywort (*Cerinthe major* L.); long-rooted geranium
(*Geranium macrorrhizum* L.); turban ranunculus, double form (*Ranunculus asiaticus* L.
'Double red'); flesh fly (family *Sarcophagidae*, possibly *Sarcophaga carnaria*). (RL 24325)

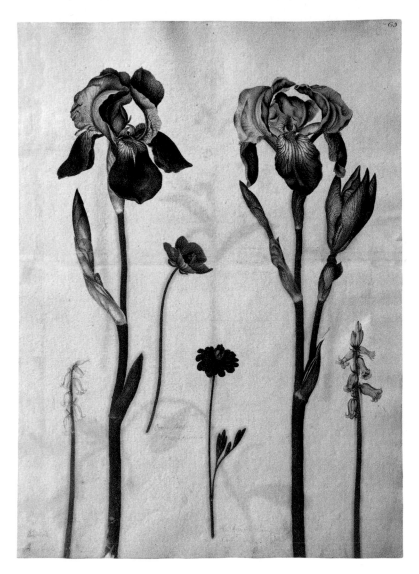

Folio 63 Left to right: bluebell, white form (*Hyacinthoides non-scripta* [L.] Rothmaler *alba*); common German flag (*Iris germanica* L.); Montpellier ranunculus or crowfoot (*Ranunculus monspeliacus* L.); turban ranunculus or crowfoot (*Ranunculus asiaticus* L. 'Pleniflorus'); common German flag, form (*Iris germanica* L. [form]); bluebell (*Hyacinthoides non-scripta* [L.] Rothmaler). (RL 24330)

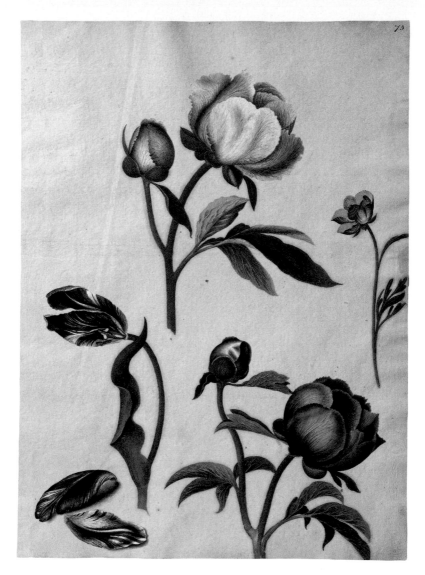

Folio 73 Clockwise from top: biternate peony (*Paeonia mascula* [L.] Miller); turban ranunculus (*Ranunculus asiaticus* L.); peony (*Paeonia officinalis* L. 'Rubra Plena'); tulip (*Tulipa gesneriana* L. cv.). (RL 24340)

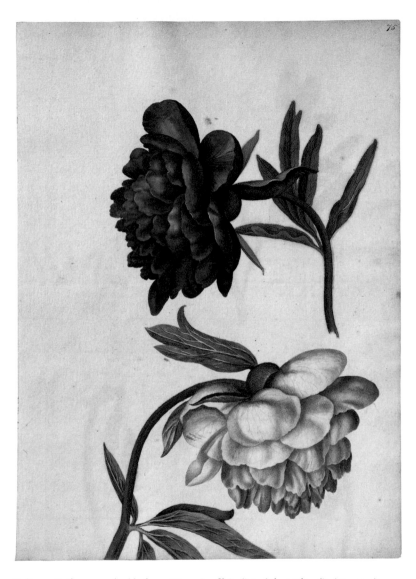

Folio 75 Both peony, double form (*Paeonia officinalis* L. 'Flore Pleno'). (RL 24342)

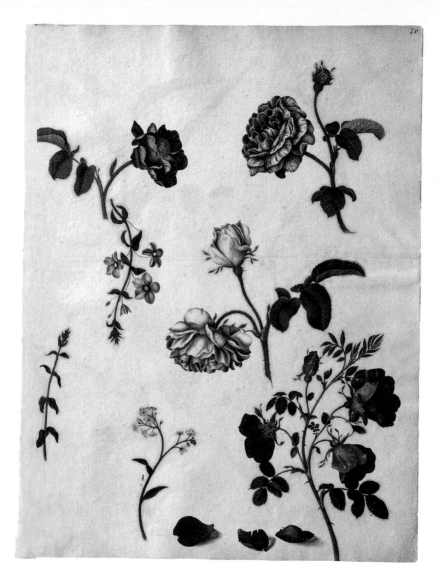

Folio 78 Clockwise from top left: velvet rose (*Rosa gallica* L. 'Holosericea');
unidentified rose (*Rosa*); damask rose (*Rosa damascena* Miller); Austrian copper rose
(*Rosa foetida* J. Herrm. 'Bicolor'); water forget-me-not (*Myosotis scorpioides* L.); blue
pimpernel (*Anagallis monelli* L.); blue pimpernel (*Anagallis monelli* L.). (RL 24345)

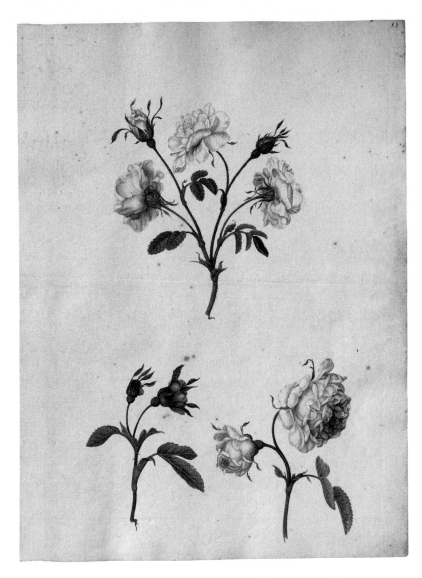

Folio 82 Clockwise from top: white rose, semi-double form (*Rosa* x *alba* L.);
cinnamon rose (*Rosa majalis* J. Herrm.); Frankfurt rose (*Rosa francofurtana* Muenchh.).
(RL 24349)

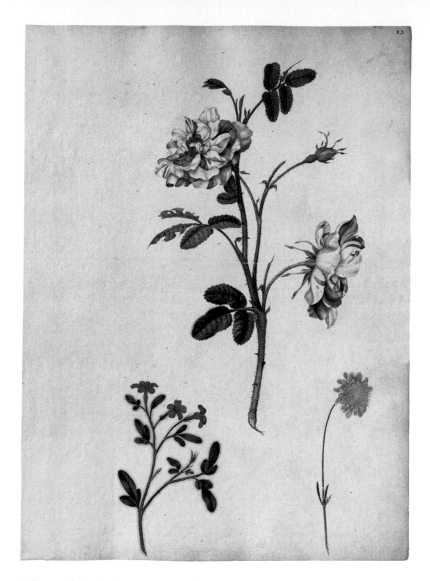

Folio 83 Clockwise from top: York and Lancaster rose (*Rosa* x *damascena* Miller *versicolor*); field scabious (*Knautia arvensis* [L.] Coulter); wild jasmine (*Jasminum fruticans* L.). (RL 24350)

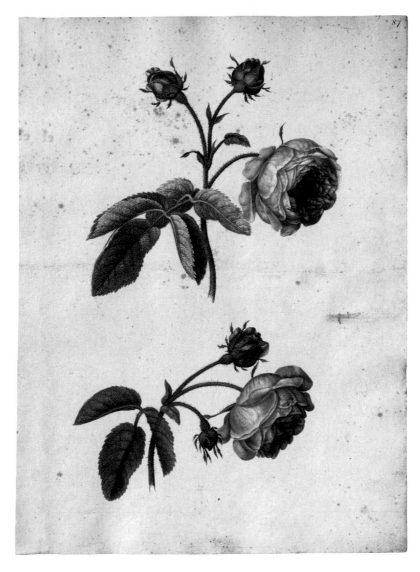

Folio 87 Both cabbage rose (*Rosa centifolia* L.). (RL 24354)

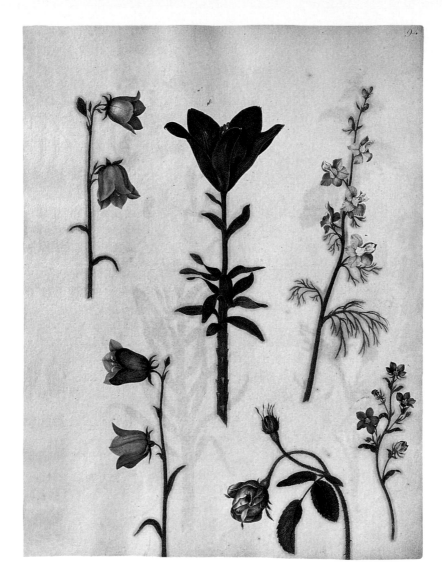

Folio 94 Clockwise from top left: peach-leaved bellflower (*Campanula persicifolia* L.);
orange lily (*Lilium bulbiferum* L. ssp. *croceum* [Chaix] Baker); larkspur (*Consolida orientalis*
[Gay] Schröd., pale form); Venus' looking-glass (*Legousia speculum-veneris* [L.] Chaix);
unidentified rose (*Rosa*); peach-leaved bellflower (*Campanula persicifolia* L.). (RL 24361)

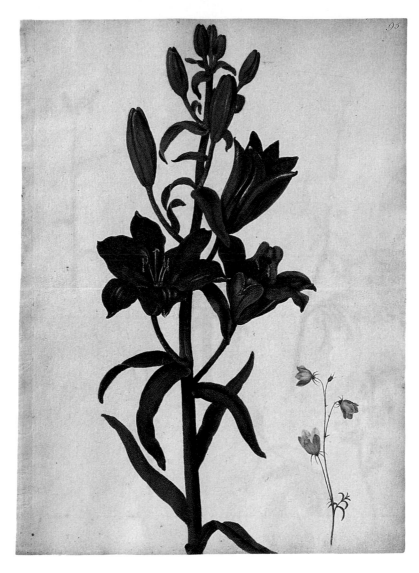

Folio 95 Left to right: orange lily (*Lilium bulbiferum* L. ssp. *croceum* [Chaix] Baker); harebell (*Campanula rotundifolia* L.). (RL 24362)

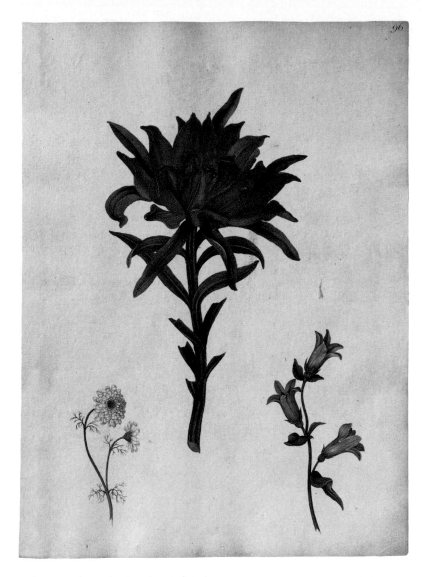

Folio 96 Left to right: feverfew, double form (*Tanacetum parthenium* [L.] Schultz 'Plena'); orange lily, double form (*Lilium bulbiferum* L. ssp. *croceum* [Chaix] Baker, double form); nettle-leaved bellflower (*Campanula trachelium* L.). (RL 24363)

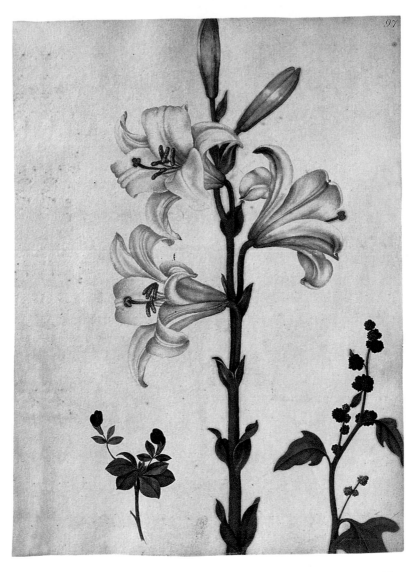

Folio 97 Left to right: asparagus pea (*Tetragonolobus purpureus* Moench); Madonna lily (*Lilium candidum* L.); strawberry blite (*Chenopodium capitatum* [L.] Aschers). (RL 24364)

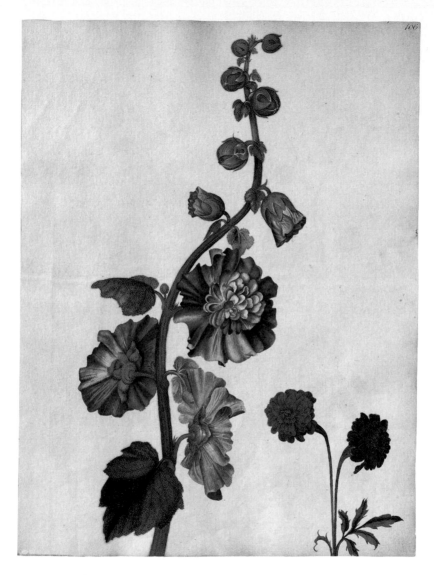

Folio 106 Left to right: hollyhock, double form (*Althaea rosea* L. 'Flore Pleno'); French marigolds (*Tagetes patula* L.). (RL 24373)

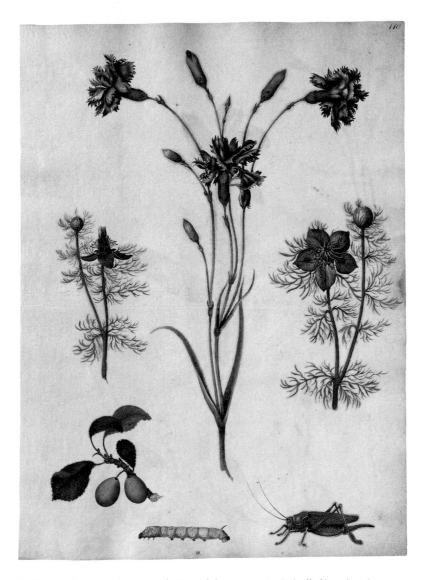

Folio 110 Clockwise from top left: Spanish love-in-a-mist (*Nigella hispanica* L.); carnation (*Dianthus caryophyllus* L. cv.); Spanish love-in-a-mist (*Nigella hispanica* L.); great green bush-cricket, female (*Tettigonia viridissima*); silkworm larva (*Bombyx mori*); bullace (*Prunus domestica* L. ssp. *institia* [L.] Poiret Bullace). (RL 24377)

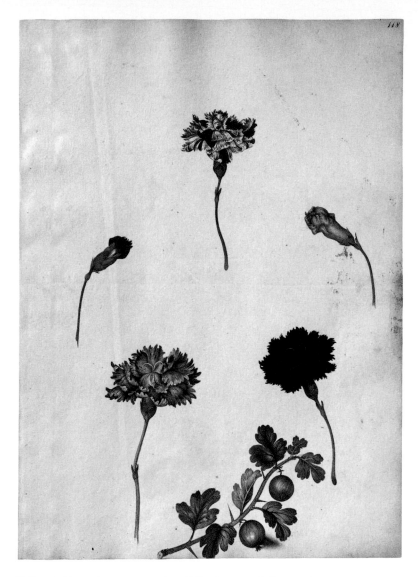

Folio 118 Top and centre: carnations (*Dianthus caryophyllus* L. cv.);
bottom: gooseberries (*Ribes uva-crispa* L. cv.). (RL 24385)

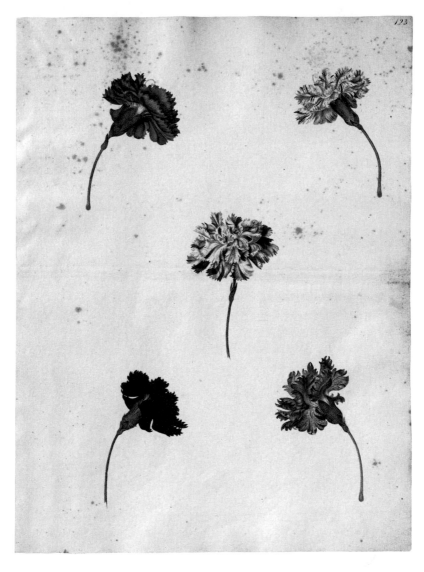

Folio 123 Full page of carnations (*Dianthus caryophyllus* L. cv.). (RL 24390)

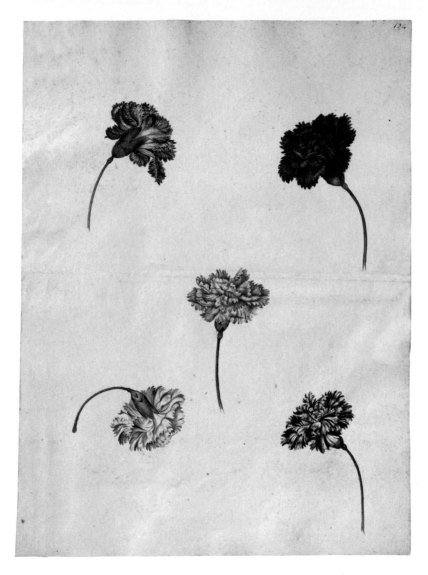

Folio 124 Full page of carnations (*Dianthus caryophyllus* L. cv.). (RL 24391)

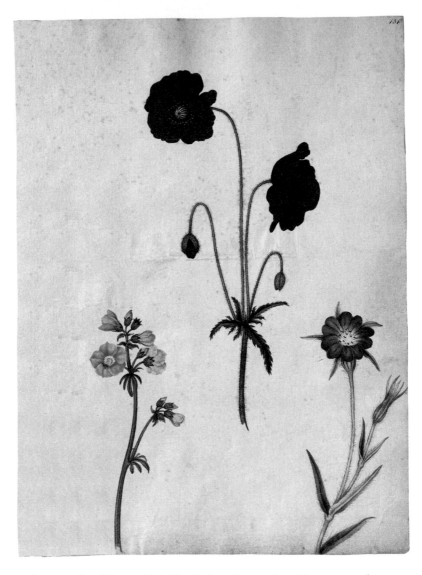

Folio 131 Left to right: Jacob's ladder (*Polemonium caeruleum* L.); common red poppy (*Papaver rhoeas* L.); corn cockle (*Agrostemma githago* L.). (RL 24398)

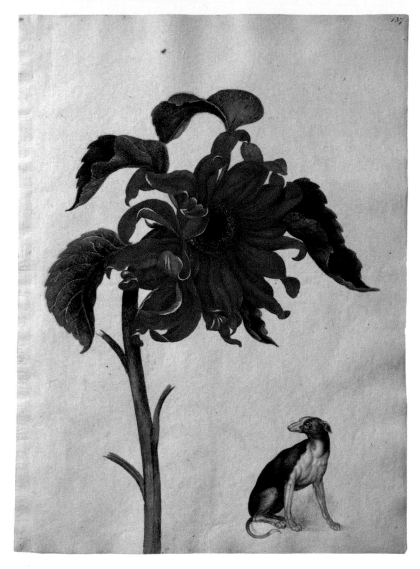

Folio 137 Left to right: common sunflower (*Helianthus annuus* L.); greyhound (*Canis familiaris*). (RL 24404)

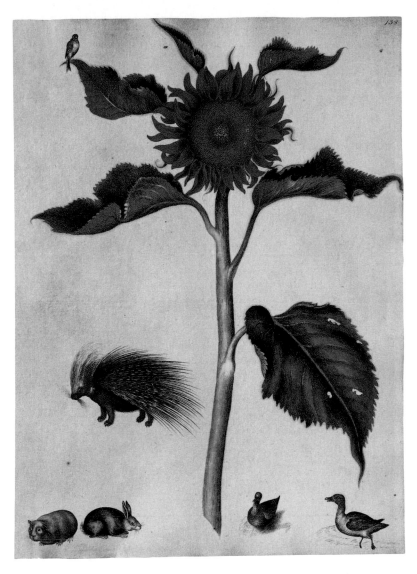

Folio 138 Clockwise from top left: goldfinch (*Carduelis carduelis*); thin-leafed sunflower (*Helianthus decapetalus* L.); domestic mallard, male (*Anas platyrhynchos*); unidentified duck (*Anas* sp.); domestic rabbit (*Oryctolagus cuniculus*); domestic guinea pig (*Cavia porcellus*); crested porcupine (*Hystrix cristata*). (RL 24405)

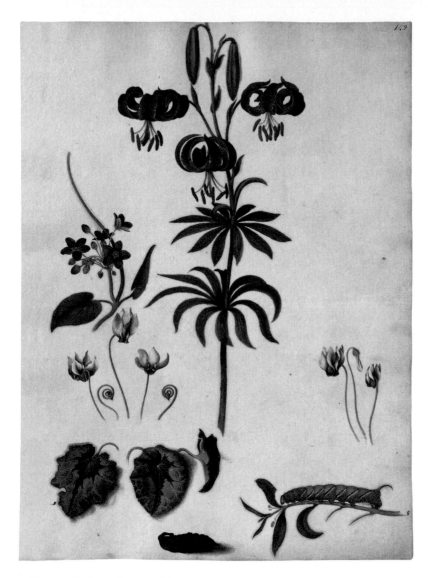

Folio 142 Clockwise from top left: guayato (*Gonolobus carolinensis* [Jacq.] Schultes); swamp lily (*Lilium superbum* L.); ivy-leaved cyclamen or sowbread (*Cyclamen hederifolium* Aiton); privet hawkmoth larva (*Sphinx ligustri*) on privet (*Ligustrum vulgare* L.); privet hawkmoth pupa (*Sphinx ligustri*); ivy-leaved cyclamen or sowbread (*Cyclamen hederifolium* Aiton). (RL 24409)

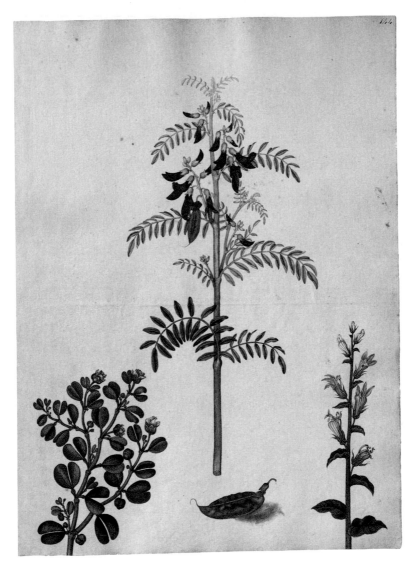

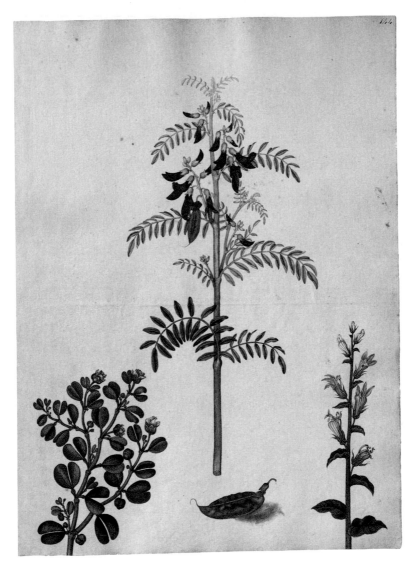

Folio 144 Left to right: Syrian bean caper (*Zygophyllum fabago* Thunb.); balloon pea (*Sutherlandia frutescens* [L.] R. Br.); blue cardinal flower (*Lobelia siphilitica* L.). (RL 24411)

187

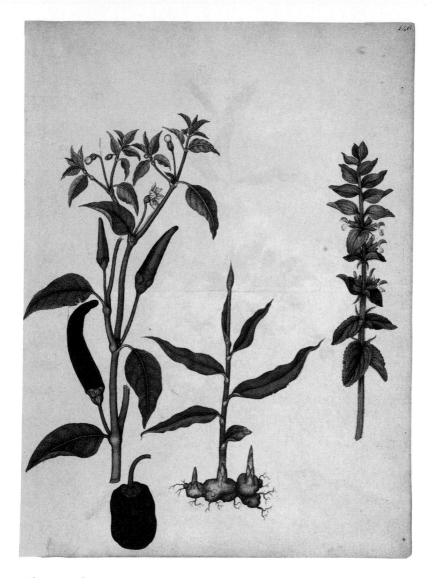

Folio 146 Left to right: hot pepper (*Capsicum frutescens* L.); sweet pepper (*Capsicum annuum* L.); ginger (*Zingiber officinalis* Roscoe); purple sage (*Salvia horminum* L.). (RL 24413)

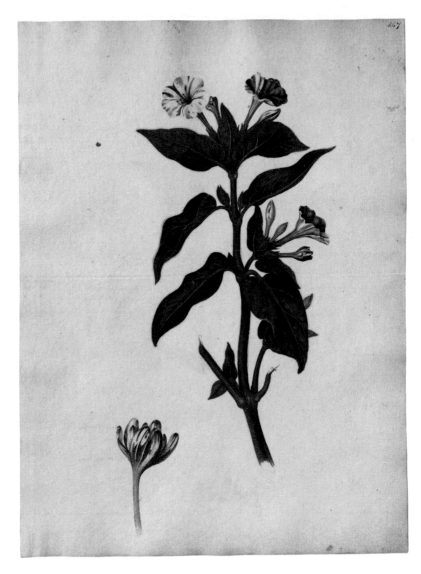

Folio 147 Left to right: meadow saffron, double striped form (*Colchicum autumnale* L. *striatum* 'Pleniflorum'); marvel of Peru (*Mirabilis jalapa* L.). (RL 24414)

FURTHER READING

Prudence Leith-Ross and Henrietta McBurney,
*The Florilegium of Alexander Marshal
in the Collection of Her Majesty The Queen
at Windsor Castle* (Royal Collection, 2000)

[This publication contains a full bibliography.]

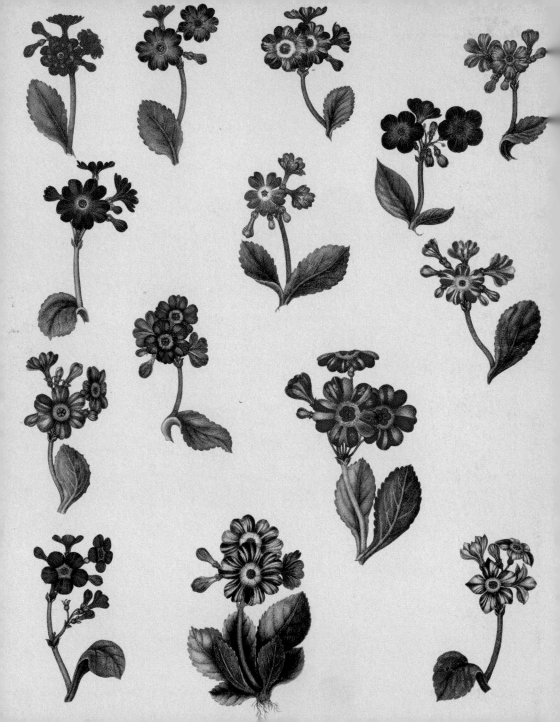